BLACK & WHITE

PHOTOGRAPHY

THE ESSENTIAL BEGINNER'S GUIDE

DAVID TAYLOR

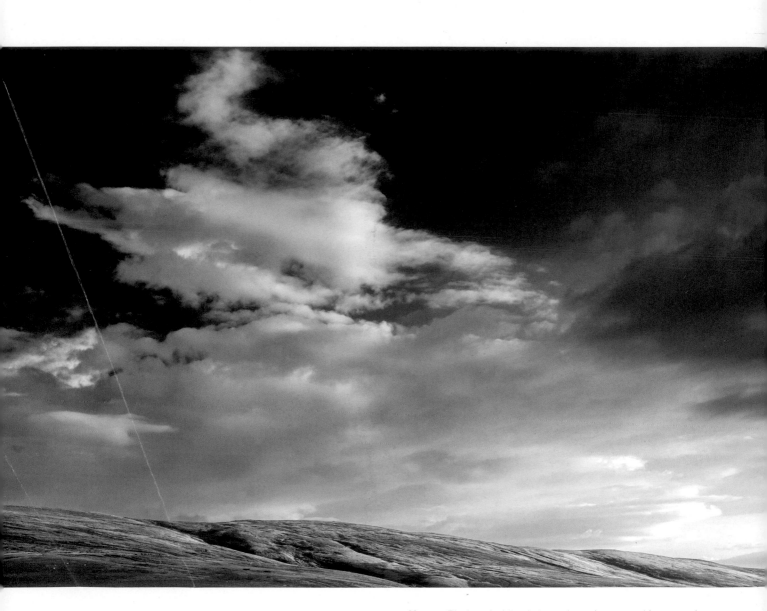

Above: Black and white photography embraces a wide range of genres and techniques. Images can be straightforward, as in this landscape, or they can be heavily manipulated to become a less literal, more subjective representation of reality. Exploring the possibilities of black and white photography is a journey for a lifetime.

BLACK & WHITE

PHOTOGRAPHY

THE ESSENTIAL BEGINNER'S GUIDE

DAVID TAYLOR

AMMONITE
PRESS

First published 2015 by
Ammonite Press
an imprint of AE Publications Ltd
166 High Street, Lewes, East Sussex, BN7 1XU, UK

ISBN 978-1-78145-090-1

British Library Cataloging in Publication Data: A catalog record of
this book is available from the British Library.

Editor: Rob Yarham
Series Editor: Richard Wiles
Cover Designer: Robin Shields
Designer: Richard Dewing Associates

Typeface: Berthold Akzidenz Grotesk
Color reproduction by GMC Reprographics
Printed in China

CONTENTS

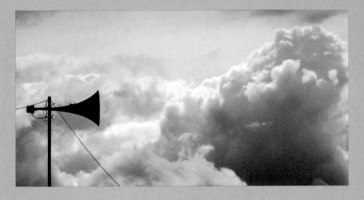

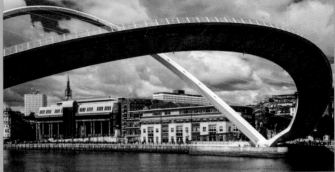

PART ONE
GETTING STARTED

The human brain is a wonderful thing (you wouldn't be able to read this book without one). It is, by a very large margin, the most complex natural structure in the universe that we've discovered so far. Arguably, the most interesting aspect of the human brain is that the left hemisphere is suited to logical reasoning and language, whereas the right hemisphere is more adept at imagination and abstract, spatially-orientated tasks.

Rather splendidly, photography calls on both of these sides of the brain. The way in which a camera operates does require some left-brain-thinking to understand. If you've a mind to, you can quickly lose yourself in a world of numbers and calculations, from shutter speeds to f-stops and ISO settings.

Although these technical aspects of photography may appear daunting, there's a logic to them that can be learned through practice. All photographers struggle through this, so if you find the technicalities of photography a puzzle, take heart from the fact that you're not the first.

The more artistic side of photography is the province of the right brain. Composition involves thinking about space and how elements of a potential photograph are arranged within that space. The more imaginative aspects of photography are possibly more difficult to understand than the technical. But again, with practice and a willingness to learn, they can be mastered.

This book is an introduction to black and white photography. It's a fascinating subject that really will stretch your gray cells. You'll need the imagination to see the world in a way you've never seen it before. Not only that, but you'll be required to make artistic and aesthetic decisions, both at the moment of exposure and during the postproduction process of creating a black and white image. But it's a worthwhile and fascinating journey to embark on.

It's a journey that starts in Part One of this book, where we'll look at the basics of photography. In Part Two, we'll delve into the world of shooting and exposure. Part Three covers working with black and white images. Finally, in Part Four, we'll consider some of the different genres of photography and their potential for creating striking black and white imagery.

David Taylor

Left: All photographers need to know the basics of their craft. However, the images you create will be shaped and influenced by your own personal interests. My particular fascination is with landscape photography. It's a photographic genre that I find endlessly fascinating and challenging.

CHOOSING A CAMERA

Black and white photography doesn't require the use of esoteric photographic equipment. If you have a camera, lens, and memory card, then you're ready to begin shooting. That doesn't mean that there aren't other useful pieces of equipment that would expand your photographic world, as we'll discover later on.

CAMERAS

When it comes to cameras we're spoilt for choice in the 21st century. Cameras come in all shapes and sizes, from those built into cellphones to professional-grade digital single-lens reflex (DSLR) cameras. Every type can be used to shoot black and white images. Cellphone cameras—particularly those found on smartphones—have a lot of advantages. They're a camera that you can keep with you at all times. This makes them suited to unexpected photo opportunities, when you'd be less likely to have a "normal" camera with you. It's no coincidence that news reports increasingly feature timely, on-the-spot cellphone imagery.

If you use a smartphone you can also take advantage of the astonishing number of photographic apps available to modify your images as you shoot. Instagram and Hipstamatic are probably the two most popular apps, but there are hundreds more—many of them free (though often

with limited features until you buy an upgrade). Black and white photography is well served. There are apps that will simulate particular film types or darkroom processes such as cyanotype (see page 107), all found relatively easily through Apple iTunes or Google Play (for iOS or Android smartphones respectively). Purists may scoff but apps are a fun and inexpensive way to experiment with black and white photography. The drawbacks to using a cellphone are the fact that you have a fixed lens, low light capabilities aren't great, and images (with a few exceptions) are generally low-resolution and saved in a highly compressed format using JPEG (see page 70).

COMPACT CAMERAS

Above: High-end compact cameras, such as the Canon Powershot G16, are used by professional photographers. This is because the camera provides a level of control over its functions that rivals those of a system camera.
© Canon

The sales of compact cameras have declined in recent years due to the ubiquity of camera-enabled phones. It's not difficult to understand why this should be. Why carry two devices when one can do multiple jobs? However, there's a lot to be said for compact cameras—virtually all of them have a zoom lens, which increases the types of images that can be captured. Higher-end compact cameras also give you greater control over exposure than a cellphone—adjusting exposure compensation or the ISO to suit the ambient lighting conditions is usually possible.

Left: Tablet computers and devices such as camera-enabled MP3 players can also be used to shoot black and white photos. This image was shot with an Apple iPod Touch and processed using the Old Photo Pro app by Deion Mobile.

A well-specified compact camera may also allow you to shoot using Raw format (see page 70). This will unlock greater potential for how an image is converted to black and white in postproduction. This is necessary because compact cameras tend to have very limited options for shooting directly in black and white. There'll be a basic black and white mode, and, if you're lucky, there'll be an option for tinting images as you shoot, typically sepia and a cool tone such as blue. That said, a lot of compact cameras have creative modes that allow you to add grain to an image or simulate a specific camera type such as a "toy" or pinhole camera. However, these modes don't use Raw and so the effects can't be undone after shooting. They're fun to use, however, as long as this limitation is understood.

Above: Cellphones and compact cameras both typically suffer from sensors with a limited dynamic range, especially when compared with system cameras. This means that more care has to be taken with exposure, particularly when shooting into a high-contrast scene such as this. See page 30 for more information on dynamic range.

NOTE

See the following pages for more information about:
Exposure compensation–page 20; ISO–page 28; and Raw/JPEG–page 70.

SYSTEM CAMERAS

Above: There's quite a size difference between a mirrorless camera, such as the Olympus PEN E-P5 (left), and a full-frame DSLR, such as the Nikon D810. Despite this, they both fulfil essentially the same task—which one is the right tool for the job depends on the job.
© Olympus © Nikon

A system camera can accept interchangeable lenses as well as other accessories such as flashguns. There are two types of system camera currently available: digital single lens reflex (or DSLR) and mirrorless (also referred to as MILCs for mirrorless interchangeable lens cameras, or CSCs for compact system cameras). As with many aspects of photography there's no clear-cut answer to which is the "best" choice. Ultimately, personal preference should be the main guide when choosing a system camera. The ergonomics of a camera should also be taken into account.

DSLRs feature an optical viewfinder (OVF). The image from the lens is passed through to the viewfinder via a mirror and pentaprism. When the shutter button is pressed the mirror swings out of the way, the shutter opens, and light is allowed to fall onto the sensor to make an image. When the exposure is complete the shutter closes and the mirror swings back into place. The advantage to this complex system is that it allows you to see exactly what the sensor "sees". Optical viewfinders also have a crispness that—so far—electronic viewfinders (EVFs) have yet to match. The disadvantage is that DLSRs are typically more bulky than an equivalent mirrorless camera. DSLRs are often based on systems devised in the film era. This means that DSLRs are one component of a mature system—it's easy to find old secondhand equipment that will work perfectly with a DSLR. Mirrorless cameras are purely products of the digital era, so the ranges of accessories—

particularly lenses—tend to be smaller, although the choice is now catching up with those available for DSLRs.

As the name suggests, mirrorless cameras make do without the mirror found in DSLRs. A live image feed is sent directly from the sensor to the EVF (or rear LCD). This makes a mirrorless camera significantly less mechanically complex than a DSLR. This should mean that mirrorless cameras are cheaper than DSLRs, but curiously this isn't necessarily the case—some high-end mirrorless cameras are more expensive than comparable DSLRs. For the black and white photographer, mirrorless cameras do have one advantage—by setting the camera to shoot in black and white (in JPEG format only) you can see what the effect will be as you compose your image. This is especially useful if the camera has an EVF. It's possible to do something similar with a DSLR set to Live View on the rear LCD, but this isn't ideal for viewing images, particularly in bright light.

SENSOR SIZE

A major difference between camera types is the size of the image-forming sensor in the camera. The sensors inside cellphones and compact cameras are often no bigger than a fingernail. System cameras (with the exceptions of Nikon's CX and Pentax's Q cameras) have substantially larger sensors than this. The three most common sensor sizes in system cameras are: Micro Fours Thirds (17.3 x 13mm), APS-C/cropped (23.7 x 15.6mm), and full-frame/35mm (36 x 24mm). There's no right or wrong answer when choosing a camera based on its sensor size. Cameras with smaller sensors can be made physically smaller—cellphones can be easily slipped into a pocket, which is not something you can do with a DSLR. However, there's a price to be paid for this convenience.

A sensor is a grid of millions of photodiodes, which are tiny well-like structures. These photodiodes "collect" light—or more accurately, the light particles known as photons—during an exposure. This is rather like using a bucket to collect marbles. By necessity, small sensors mean that the individual photodiodes on the sensor are smaller too. During an exposure, a small sensor can't gather as much accurate image data as a larger sensor. To go back to the bucket analogy, a small bucket isn't able to hold as many marbles as a larger bucket before it begins to overflow. If you want to analyze the marbles to find out their average size and color, the more marbles you have, the more accurate your analysis would be. The larger photodiodes of a larger sensor are able to gather more photons during an exposure, and so the camera has more information to recreate a truer picture of the scene. Smaller sensors typically have a smaller dynamic range and produce more noise at a given ISO setting than larger sensors. This means that you have to be more careful and accurate with exposure when using a smaller-sensor camera.

Above: In an ideal world, you'd have different cameras for different tasks (perhaps you do). An Olympus Micro Four Thirds camera, used for this shot, has certain limitations when it comes to exposure when compared to a full-frame camera. However, it's a smaller camera and is ideal for carrying around all day.

Above: Digital black and white photography often involves altering photographs substantially in postproduction. With each step in this process the image quality decreases. It therefore pays to start with the highest quality image possible to allow for the inevitable image degradation. The lighting in this scene wasn't ideal, with bright highlights and deep shadows. Using a camera with a full-frame sensor has allowed me to extract detail from the shadows, without paying too high a penalty in image quality—something that would have been more difficult with a file from a compact or cellphone camera.

LENSES

You don't need to use special lenses to shoot black and white images. However, your choice of lenses will be dictated by your photographic interests.

FOCAL LENGTH

The focal length of a lens is a measurement of the distance (in millimeters) from the optical center of the lens to the focal plane when a subject at infinity is in focus (the focal plane of a camera is where the sensor inside is positioned). Focal length is one factor that affects the angular coverage of the lens. The angular coverage—also known as the field or angle of view—is the amount of the scene projected by the lens onto the sensor, measured in degrees. The shorter the focal length of the lens, the wider the angular coverage. A short focal length lens is known as a wide-angle lens for this reason. The longer the focal length, the narrower the angular coverage and the greater the magnification of the image on the sensor. Long focal length lenses, commonly referred to as telephoto lenses, enable you to shoot your subject from a distance while still keeping it relatively large in the frame.

Above: This image was shot on a full-frame camera using a 100mm lens. If I'd fitted the same lens to an APS-C camera (and stood in the same position), the angle of view would be confined to the green box. On a Micro Four Thirds camera, the angle of view would have been smaller still, reduced to the inner red box.

Just to complicate life, the size of the sensor inside the camera also has an effect on the angle of view captured during exposure. The smaller the sensor, the narrower the angle of view at a specified focal length. The standard reference point for sensor size is full-frame. A 35mm lens has an angle of view of 64° when fitted to a camera with a full-frame sensor. However, when fitted to a camera with an APS-C sensor, the angle of view drops to 45° (making the lens less "wide"). When fitted to a Four Thirds camera, the angle of view is smaller still, at 34°. To match the angle of view of a 35mm lens on an APS-C camera you'd need to use a 24mm lens, and on a Micro Four Thirds camera an 18mm lens.

> **NOTE**
>
> Focal length also has an effect on depth of field at a given aperture. See page 24 for more information.

ZOOMS VERSUS PRIMES

The most common type of lens is the zoom lens, which has a variable focal length. "Kit lenses" sold with cameras tend to be zoom lenses, and they usually cover a focal length range from a moderate wide angle to a short telephoto. Kit lenses are ideal first lenses, but they're typically not the best equipment—either optically or in terms of build quality—in a manufacturer's lens range. Another limitation is that they have relatively small maximum apertures, making them less useful in low light or when you want to limit depth of field (see page 24). Ultimately, you get what you pay for with a lens. Manufacturers usually make far more complex and better-quality zoom lenses than their kit lenses, but these are invariably more expensive. The key to buying lenses is to think carefully about your style of shooting and to match the lenses you buy to suit you—for

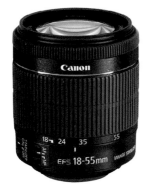

Above: The Canon 18–55mm IS STM is a good example of a kit lens commonly sold as a package with a Canon camera.
© Canon

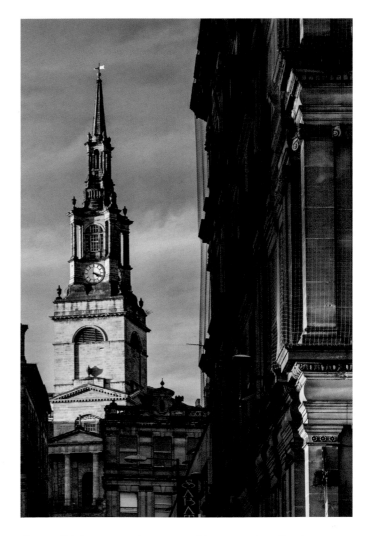

Above: This image was shot using a 100mm prime lens. It's a lens I use a lot and so I find it easy to pre-visualize compositions before taking the photograph.

example, if you're not a wildlife or journalistic photographer, a long focal length telephoto lens will not be appropriate.

An interesting alternative to the zoom is the prime lens, which has a fixed focal length. If you want to get closer to or further or away from your subject, you have to physically move—you don't have the easy option of turning the zoom ring to alter the composition. Another drawback to prime lenses is that you need several at different focal lengths in order to match the range of even a moderate zoom. However, prime lenses do have advantages over zooms. They tend to have larger apertures than even the most expensive zooms. This makes them easier to see through and focus in low light. It also means that it's easier to restrict depth of field for aesthetic reasons.

Finally, a slightly odd—but useful—advantage of using prime lenses is that you soon tune in to their individual angle of view. This makes it easier to "pre-visualize" an image—or imagine your composition—before you've brought the camera up to your eye. Street photographers often use prime lenses for this very reason, when there's often little time to refine a composition by turning a zoom ring.

SOFTWARE

Black and white images can be shot in-camera, reducing the need for conversion in postproduction (when shooting JPEG). However, if you shoot in color or in Raw you'll need some form of conversion software to create your black and white images.

The most well known graphics application is Adobe Photoshop. Photoshop is a highly complex package aimed at a variety of users—not just photographers. For that reason, learning how to use Photoshop can be a daunting prospect. One useful aspect of Photoshop is that its capabilities can be expanded with the addition of third-party apps, called "plug-ins". For instance, Silver Efex Pro by Nik Software and Exposure by Alien Skin Software both allow you to take fine control of black and white conversion, and are even able to emulate the visual characteristics of a range of black and white film types. Photoshop Elements is a cut-down version of Photoshop, and is easier to use, although it's still possible to achieve quite sophisticated black and white conversions.

Adobe Lightroom uses Photoshop's core technologies but packages them in a way that's more photographer-friendly. Like Photoshop, Lightroom also allows you to install plugins to expand the software's capabilities. Both Photoshop and Lightroom are available by signing up to Adobe's Creative Cloud subscription service. This means paying a fee each month to use the software—stop paying and you lose the ability to process your images. The upside to this is that upgrades to the software are automatically installed so that you're always up-to-date (Elements is still—for the moment—available for a one-off fee).

If your camera supports Raw, it will come with the camera manufacturer's own Raw-conversion software. This software varies in quality, but it does have the advantage of being free. Other options include the highly regarded Capture One by Phase One, available in two versions—Pro and Express. Pro is aimed at professional users and is therefore more expensive than Express. Both are available on a 30-day trial basis. GIMP is a rival to Photoshop and supports both Raw and JPEG file formats. GIMP is open-source software developed by unpaid programmers, and is free to download and use. Another free option—though far more basic than GIMP—is iPiccy, which is cloud-based software for uploading and editing your photos online. A similar approach is taken by Google's Picasa and Adobe's Photoshop Express, both of which also allow you to edit your images online.

Above: Adobe Express is Adobe's free, online image-editing tool.

FILTERS

A filter is a sheet of translucent material that affects light as it passes through the material. Mention filters to a non-photographer and they'll probably imagine gruesome effects filters which add unnatural colors to an image. Fortunately, filters can be used for far more subtle purposes than this. Some types of filters are almost indispensible for certain genres of photography. A good example is the neutral density (ND) filter commonly used by landscape photographers to expand their exposure options. Slightly counter-intuitively you can use colored filters to great effect when shooting black and white images in-camera (see page 70).

Filters come in two forms: circular with a screw mount for fitting directly to a camera lens, and square for fitting into a filter holder (which is attached to the camera lens with an adapter ring). Both types have advantages and disadvantages. Screw-in filters are relatively cheap and easy to find. Their main disadvantage is that there is no standard lens filter thread size—lenses come in all shapes and sizes. If you have several lenses, it's often necessary to buy the same filter type in several different sizes. The solution is to buy the filter that fits the largest filter thread and then use step-down rings to fit the filter onto your other, smaller lenses. Leading screw-in filter manufacturers include B+W, Hoya, and Kood.

Buying a filter holder with a few filters is initially a more expensive way to build up a filter collection. This is compounded by the fact that it's more difficult to mix and match filters produced by different manufacturers. The two main manufacturers of filter holders are Cokin and Lee. Cokin produces four sizes of filter holders: the 67mm A-system; the 84/85mm P-system; the 100mm Z-Pro system; and the 120mm X-Pro system. Lee produces two sizes of filter holder: the 75mm Seven5 system, designed for compact and mirrorless cameras, and the 100mm system, designed for DSLRs. The general rule is that the bigger the system, the more expensive the filters. However, it's worth the extra expense of buying a larger filter holder. Using ultra-wide-angle lenses with smaller filter holder systems is either physically impossible or causes unacceptable vignetting in the corners of images (due to the fact the lens can "see" the filter holder).

Above: Lee filter ring—the ring clips onto an inexpensive adapter fitted to the filter thread of the lens.

FILTER TYPES

A neutral density filter is a slightly opaque filter that reduces the amount of light reaching the sensor inside the camera. They're typically used in bright conditions when it would otherwise be impossible to achieve a desired level of exposure. ND filters are typically used to extend shutter speeds so that movement in a scene can be blurred (see page 26). ND filters are sold in a variety of strengths measured in stops. The stronger the filter, the more opaque it is and the greater the effect on the camera's exposure.

There's a current vogue for extremely dense ND filters, such as Lee's "Big Stopper" that offers 10-stops of filtration. This allows you to extend shutter speeds to whole seconds, sometimes even minutes, depending on the ambient lighting conditions. The effects on a moving subject are pronounced. Water and clouds become misty and soft, with all sense of texture smoothed away. It's an effect that's arguably more suited to black and white photography than color because of the way it abstracts reality. Because of their density, it's impossible to see through an extreme ND filter and so composition and focusing must be set before the filter is fitted.

The ND graduated filter differs from the standard ND filter in that only the top half the filter is semi-opaque, while the bottom half is completely transparent. "ND grads", as they are also known, are used to balance out exposure when one area of a scene is far brighter than another, such as a sky above a landscape (particularly if the landscape is in shadow). As with ND filters, ND grads are available in different strengths (also measured in stops). The greater the difference in exposure, the stronger the ND grad filter you would need to use.

A polarizing filter cuts out reflections on non-metallic surfaces at roughly 35–45° to the surface. This is useful for helping to add clarity to water or wet foliage and to glossy still-life subjects. A polarizing filter will also deepen the blue of the sky at 90° to the sun. This helps to increase the contrast between the sky and any clouds in the sky. When the image is converted to black and white the use of a polarizing filter will make it easier to achieve a darker sky tone. Polarizing filters are made of glass, mounted in a rotating frame. The effectiveness of the filter can be adjusted by rotating the frame.

NOTES

- It's possible to use more than one filter by stacking one on top of another. However, use more than two or three filters and image quality may be seriously compromised.

- Photographers often fit ultraviolet (UV) filters to their lenses to protect the front elements of the lenses (the filter has no effect on exposure). UV filters block UV light and help to cut through atmospheric haze.

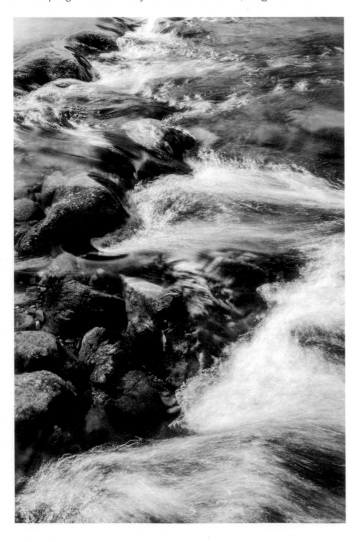

Left: A polarizing filter was used when shooting this image, primarily to remove a distracting glare from the surface of the water, but it also added clarity to the rocks in the river. However, polarizing filters are slightly opaque and can be effectively used as ND filters too—this allowed me to use a longer shutter speed than would otherwise have been possible.

SCANNERS

You don't need a camera to make digital black and white images. Flatbed scanners, although much more limited in ability and range of functions than a camera, can also be used to produce interesting imagery.

The main restrictions for using a scanner are that your subject must be relatively flat and not too heavy—you really don't want to crack the glass of your scanner. With imagination, however, these restrictions aren't too onerous.

There are two important specifications that will determine how effective your scanner is. The first is its resolution. This is measured in dpi or dots per inch—which indicates how many pixels of image information a scanner can resolve for every inch scanned. The higher the dpi, the more detailed your scans will be. The practical upshot of this is that you'll be able to make bigger, higher quality prints from the scanned image later on.

The second specification is the D-Max—a measure of a scanner's dynamic range (see page 30). The higher a scanner's D-Max, the more tonal information it will be able to capture from the subject being scanned.

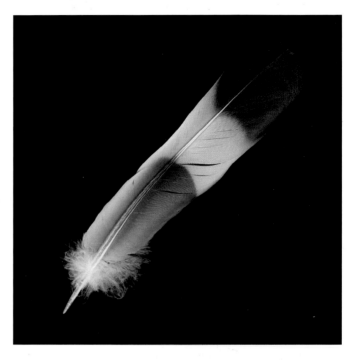

Above: Simple subjects work well when scanned. I used an open box to create the clean black background for this image of a feather. The inside of the box was painted matte black to avoid any light from the scanner reflecting on the inside of the box. The open end of the box was then placed on the scanner over the subject before scanning.

NOTES

- Some scanners appear to have very high dpi figures. However, these are often not what they seem. The most important figure is a scanner's optical dpi. Higher dpi values than this are created by digital interpolation—the technique of increasing the number of pixels in an image by the scanner calculating what color pixels should fill the gaps. Interpolation works, but it can degrade image quality and is something that's often better achieved using your image-editing software later.

- Scanners are ideal for creating photograms (see page 108 for more information).

OTHER ACCESSORIES

It's possible to go slightly crazy when buying accessories for a camera. In truth, you can shoot just as efficiently with the bare minimum of equipment. However, there are certain accessories that will make life much easier and there are others that will help you to shoot in ways that would be impossible otherwise.

MEMORY CARDS

There are two factors to be considered when buying a memory card: the capacity and the read/write speed. Capacity is the amount of space available for storing your images. Put simply, the bigger the memory card, the more images you'll be able to store on it. This is particularly important if you shoot Raw, as a Raw file typically takes twice as much space on a card as an equivalent JPEG. However, although memory cards are robust, they can go wrong. Some photographers therefore prefer to use a number of smaller-capacity cards rather than just one large card. If one card out of several fails it's a problem, but it's a smaller problem than if your only card fails.

The read/write speed determines how quickly image data can be written to and read from the card. A slow card can cause a bottleneck, particularly if you're shooting continuously. It can be frustrating when your camera locks up and you are unable to continue shooting because it's too busy writing files to the card. However, if your style of photography is more careful and sedate, the cost savings of a slower card may be worthwhile.

TRIPOD

A tripod is a necessity for certain types of photography. For instance, landscape photography often requires you to shoot in low light and, even with image-stabilized equipment, it's difficult to handhold a camera successfully—particularly as the use of small apertures is necessary for increased depth of field.

Tripods come in all shapes and sizes. Ideally you should use one that reaches eye-level without the use of the center column—a tripod is marginally less stable with the center column raised than when it's lowered. However, long-legged tripods can be expensive and bulky, so height is one compromise you may need to make—it will all depend on how often you think you'll use a tripod and how far you'll need to carry it.

The weight and stability of a tripod are affected by the materials it's made from. Plastic tripods are very lightweight (and relatively inexpensive) but can be easily tipped or blown over. Metal tripods—typically aluminium—are more stable but are also far heavier. Carbon-fiber tripods offer excellent weight savings compared to their metal counterparts, and are also very stable. Their drawback is cost—they're typically twice the price of a metal equivalent—but it's a cost that may be worth paying if you find yourself carrying your tripod all day long.

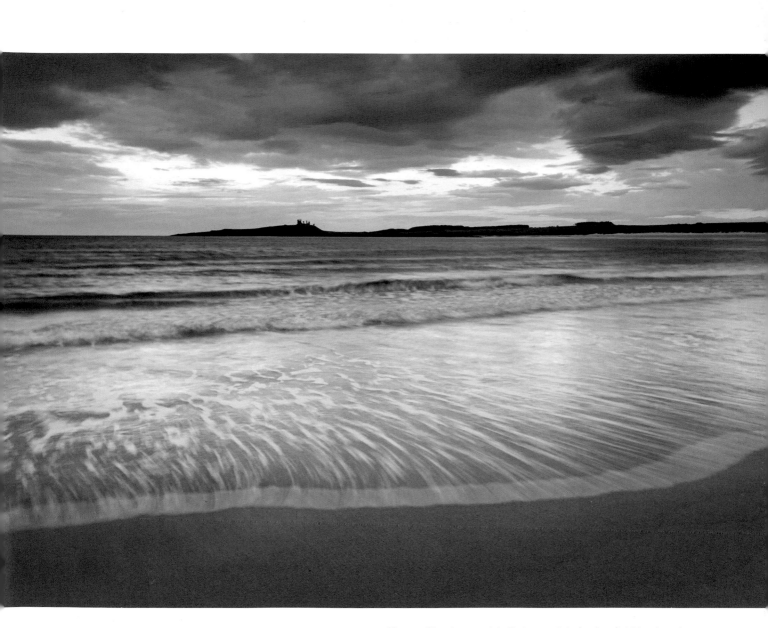

Above: Tripods come into their own at dusk, when light levels make handholding a camera impossible without resorting to increasing the ISO drastically.

UNDERSTANDING EXPOSURE

To make an exposure is to allow light to reach the sensor—or film—inside a camera and form an image. However, exposure also refers to the act of measuring how much light is needed to successfully make an image.

BASICS

When stripped down to its essentials, a camera is a box with a hole in it to allow light to reach a light-sensitive surface inside—this is literally true of pinhole cameras, which are as simple as that basic description suggests. Your camera is more sophisticated, of course. For one thing, there's a lens that focuses light to produce a sharp image. Inside the lens is a control device called the aperture, which can be varied in size (though never completely closed) to allow very precise amounts of light into the camera.

In front of the sensor is a metal curtain known as the shutter. This is opened—and then held open—for very precise periods of time. Once that period of time (known as the shutter speed) has elapsed the shutter is then closed to end the exposure and to prevent any more light from reaching the sensor.

It's the combination of how wide the aperture is set and how long the shutter is open that determines the amount of light reaching the sensor to make the exposure. A third exposure control—ISO—sets how sensitive the sensor is to light. The ISO setting chosen by you or your camera determines how much light is needed to make a satisfactory exposure. This affects the size of the aperture and the shutter speed.

METERING

The amount of light required for a satisfying exposure is determined by an exposure meter. There are two types of exposure meter: incident and reflective. An incident light meter is a handheld device that measures the amount of light falling onto a scene. A reflective meter—the type that's built into cameras—measures the amount of light that's reflected by the scene. It's a small but important difference.

Reflective metering is generally accurate and reliable. However, reflective meters work on the assumption that the scene being metered has an average reflectivity. Generally this is the case but there are certain types of scene that can fool a reflective meter. A scene with a higher-than-average reflectivity will potentially cause a reflective meter to underexpose. In the landscape this occurs when shooting snowy or sandy scenes. In the studio, a white background will have the same effect, particularly if it's larger in the image than the subject. A scene with a lower-than-average reflectivity will generally cause a reflective meter to overexpose. Shooting in any of these situations means adjusting the exposure to compensate for the errors caused by the metering.

Incident meters don't suffer from these problems. However, they're less convenient as there are more steps to work through before the shutter is fired (you need to take a meter reading, note the results, then set the recommended shutter speed and aperture manually on the camera—there's no automation with this sort of light meter).

> **NOTES**
>
> - As camera meters aren't perfect, cameras have a built-in function called exposure compensation to let you adjust the level of exposure. Increasing the level of exposure (brightening the image) is known as setting positive compensation; decreasing the level of exposure (darkening the image) manually is known as setting negative compensation. Exposure compensation can also be used to deliberately lighten or darken an image to achieve a particular effect.
>
> - Another useful function is "auto exposure bracketing" (or AEB). AEB forces the camera to shoot three (or more) images: one at the correct level of exposure, one with negative compensation applied, and the third with positive compensation applied. AEB is a useful way to ensure that you have at least one image correctly exposed, although note that, as the camera shoots more than one image, your memory card will fill quickly.

Left: Making a photo means thinking carefully about the effects of altering the shutter speed, aperture, and ISO. For this image, ensuring front-to-back sharpness was the key factor in deciding the exposure settings.

METERING MODES

The basic principle behind making an exposure reading using a reflective meter is reasonably straightforward. However, just to confuse matters, cameras typically have three different metering modes. The default is usually "evaluative", or matrix or multi-pattern metering, and this is the sensible option for most camera metering. However, there are some situations where it's less effective, so you need to choose center-weighted or spot metering instead.

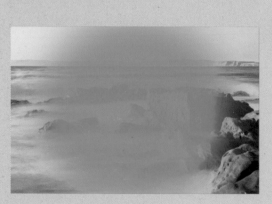

Evaluative metering (top) works by dividing the scene being metered into a large grid of cells (the number of cells varies depending on the camera model). Each cell meters its individual area of the scene independently of the others. The information from each cell is then assessed by the camera, which makes a very intelligent "guess" as to the type of scene being shot—for instance, if the bottom half of the image is darker than the top half then the camera knows that it's more likely that you're shooting a landscape than a portrait. This "guess" influences the final exposure. Often the exposure is also biased more to the results from the cell closest to the focus point too. This last factor can cause Evaluative metering to be inconsistent, particularly if the brightness of the area under the focus point is constantly changing.

Center-weighted metering (center) is, as the name suggests, a metering mode that's biased more to the center of the image than the periphery—this central bias can be as high as 60%. Center-weighted metering is most useful if you're shooting a centrally placed subject of average reflectance. Because center-weighted metering works in a very predictable way—unlike evaluative metering—it's often easier to judge when a scene will cause exposure problems and adjust exposure compensation accordingly.

Spot metering (bottom) constrains the metering to a small area of the image only—generally about 1-5% of the image area. Most cameras spot meter from the very center of the image only, the area marked by a circle in the viewfinder. More sophisticated systems allow you to meter at the active focus point.

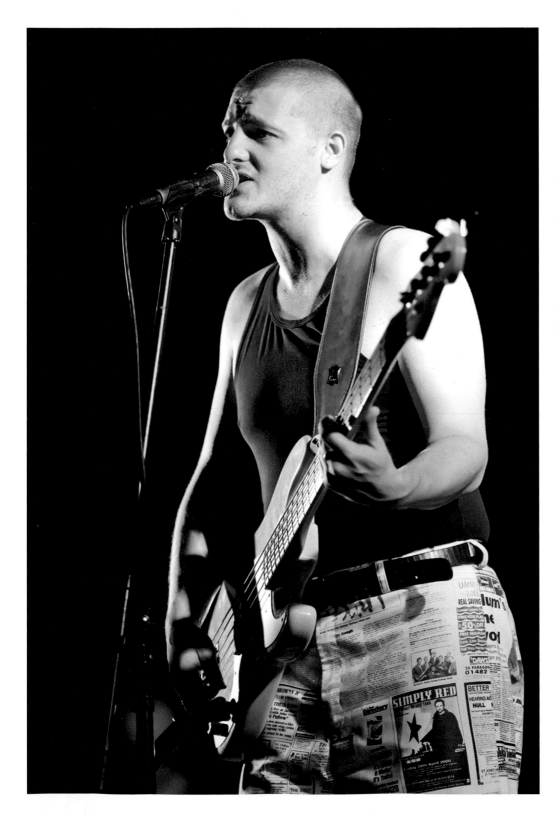

Left: Spot metering comes into its own when large areas of dark or light tones may skew the results from evaluative or center-weighted metering. The dark shadows around this floodlit performer caused problems when metering using evaluative metering, including fluctuating meter readings as the performer moved around and gross overexposure. Switching to spot metering allowed me to meter very precisely from the performer only. However, when spot metering you still need to meter from a mid-tone. Caucasian skin is slightly lighter than a mid-tone so I had to apply 2/3-stop positive exposure compensation.

APERTURE

The aperture inside the lens can be altered through a series of discrete steps to finely control the amount of light that enters the camera. These steps are referred to as f-stops (shown as "f/" followed by a number).

Maximum aperture is the term used to describe the widest aperture setting; minimum aperture describes the narrowest setting. For example, a typical range of f-stops on a lens would run, from maximum to minimum: f/2.8, f/4, f/5.6, f/8, f/11, f/16, and f/22. Reading from left to right, each f-stop value in the sequence represents a halving of the amount of light that's allowed inside the camera. Read the sequence from right to left and the amount of light doubles each time. This control of light—the act of halving or doubling the amount of light allowed to reach the sensor—is an important one, and is known as altering the exposure by one stop. It applies equally to a camera's shutter speed range, as we'll soon see.

You'll have noticed that the maximum aperture in the sequence above is a smaller number than the minimum, which may seem counter-intuitive. However, there is a reason for this: an f-stop value is actually a fraction. It represents the focal length of a lens divided by the physical width of the aperture. So, for example, when the aperture on a 100mm lens is 12.5mm in diameter, the f-stop value is f/8 (that is 100/12.5=8). When the aperture is 25mm in diameter, the f-stop value is f/4 (100/25=4).

DEPTH OF FIELD

As well as adjusting exposure, the aperture has another role to play. It controls the extent of a zone of sharpness known as depth of field. The sharpest part of a picture is always at the point of focus (although this is a slight simplification as the point of focus is actually a thin plane of focus parallel to the camera). On a simple lens, sharpness doesn't extend much further than the point of focus. However, as you make the aperture smaller on a camera lens, depth of field extends out from the point of focus,

Above: The aperture setting on most camera systems is altered by turning a dial on the camera body. Some older lenses and camera systems such as Fujifilm's X-series feature aperture rings on the lenses themselves.
© Fujifilm

increasing the depth of field throughout the image (though this extension of depth of field isn't equal on both sides of the point of focus—depth of field always extends twice as far back from the point of focus than it does forwards).

There are two other factors that determine how much depth of field is achievable at a given aperture. The first factor is the focal length of the lens. Long focal length lenses have inherently less depth of field at a given aperture than wide-angle lenses. The practical upshot of this is that it's easier to achieve front-to-back sharpness with a wide-angle lens but more difficult to restrict depth of field (with the situation reversed when shooting with a telephoto lens). The second factor is camera-to-subject distance: the closer you focus with a lens, the less depth of field is available at a given aperture. This is a particular problem when shooting close-ups. It often means that very precise focusing is required to ensure that the point of the image you want sharp is actually sharp.

NOTES

- Prime lenses typically have larger maximum apertures than zoom lenses—there are few zoom lenses with a larger maximum aperture than f/2.8. A lens with a large maximum aperture is known as "fast". Most zooms have relatively small maximum apertures and are said to be "slow".

- The aperture sequence above refers to whole f-stop values. Aperture can usually also be altered in fractions of a stop, usually either 1/2 or 1/3 of a stop.

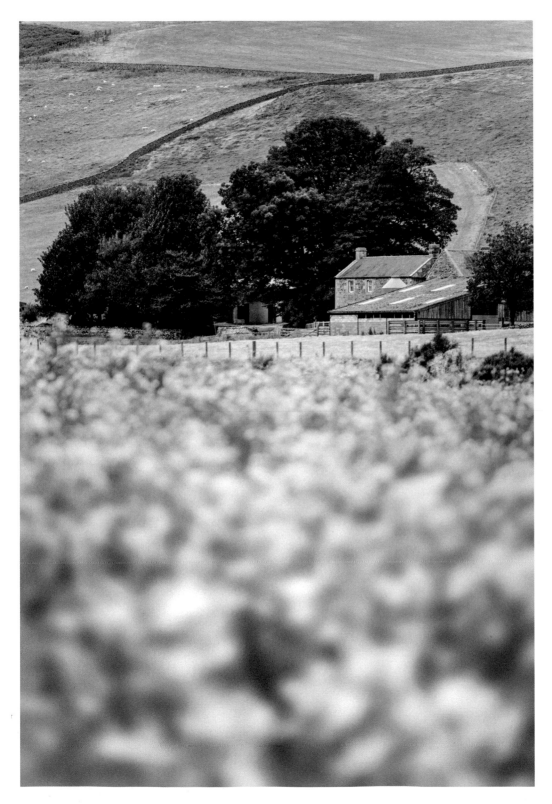

Left: The use of a telephoto lens set to its maximum aperture has allowed me to throw the foreground out of focus very effectively. The lens was focused on the farmhouse in the background to ensure that it was the sharpest part of the image.

SHUTTER SPEED

The shutter speed is set in a series of steps: 1/4000 sec., 1/2000 sec., 1/1000 sec., 1/500 sec., and so on, to 30 sec. Just like aperture, the difference between these values is referred to as a stop. When you set a faster shutter speed, each stop halves the amount of light allowed to fall on the shutter, or doubles it for each stop when you set a slower shutter speed.

Shutter speed is relatively unimportant if either the camera or the subject is static. Holding a camera by hand can often cause camera shake if the shutter speed is too long. This varies from person to person (some people are steadier than others) and is also affected by the focal length of the lens you use—the longer the focal length, the greater the risk of camera shake. Some cameras and lenses have built-in image stabilization which can help. Ultimately, however, if the shutter speed can be measured in large fractions of a second, you'll probably need to use a tripod.

If your subject is moving then the shutter speed you use will determine how your subject is recorded in the final image. Faster shutter speeds are necessary to "freeze" movement. The faster your subject, or the closer it is to the camera, the faster the shutter speed you'll need to use. Slower shutter speeds blur movement—the longer the shutter speed, the more the subject is blurred. With a sufficiently long shutter speed it's possible that your subject may even disappear from the image entirely.

NOTES

- Neutral density filters can be used to extend shutter speeds to create blur intentionally.

- Cameras usually allow you to alter shutter speeds in ½- or 1/3-stop increments. 1/1500 sec. is a half-stop between 1/2000 sec. and 1/1000 sec., for instance.

- Cameras often have a mode known as "Bulb". This holds the shutter open for as long as you keep your finger pressed down on the shutter button. This allows you to create images in very low light when shutter speeds may need to be longer than 30 sec. This won't be good for your fingers so most photographers use a remote release to lock the shutter open for the required time.

Right: The shutter speed has a big influence on how a moving subject is recorded in the final image. The first image (top) was shot using a shutter speed of 1/750 sec. This was fast enough to freeze the movement of the Ferris wheel but has made the image look oddly static. The second image (bottom) was shot with a shutter speed of 1/10 sec. This has recorded the Ferris wheel as a blur, conveying a sense of movement.

Left: This static subject could have been shot at any shutter speed and there would have been little visual difference to the shot—other than the depth of field would have altered as the aperture size would be determined by the selected shutter speed and ISO setting.

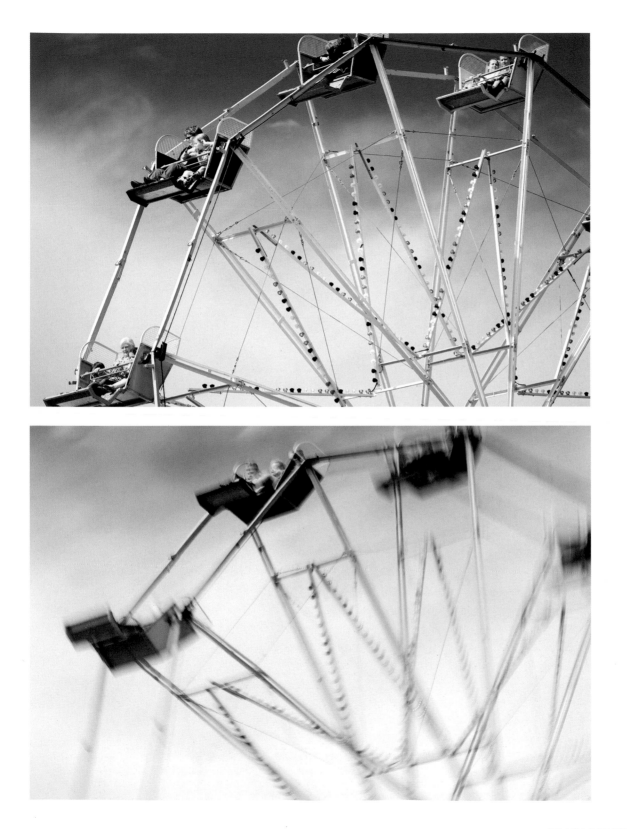

ISO

The aperture and shutter speed are physical controls that determine how much light reaches the sensor in order to make an image. A camera's ISO function determines how much light is actually needed to make that image. ISO controls a sensor's sensitivity to light. The lowest ISO setting on a camera—typically either 100 or 200 ISO—sets the sensor to its least sensitive value, meaning that a relatively large amount of light is necessary to make an image. The result is either that a longer shutter speed or a larger aperture is necessary when light levels are low.

Increase the ISO and the sensor becomes more sensitive, requiring less light to make an image. In low light this means you could use a faster shutter speed to avoid camera shake or reduce the size of the aperture in order to increase depth of field. However, if you've guessed that there's a catch, you'd be absolutely right. Increasing the ISO also increases the visibility of noise in the image. Noise is seen as a gritty texture in areas of even tone—such as sky or shadow—and, particularly when using very high ISO values, random blotches of color. In many ways this is an acceptable trade-off to ensure that images are sharp by reducing the risk of camera shake. Image noise can be removed either in-camera before shooting or in postproduction—removing the effects of camera shake is far less easy. Other drawbacks to increasing the ISO are that the sensor's dynamic range is reduced and that there's less latitude when adjusting an image in postproduction without unacceptable loss of image quality.

NOTES

- Doubling the ISO value—for example, from 100 to 200 or from 200 to 400—doubles the sensitivity of the sensor. Halving the ISO value halves the sensitivity of the sensor.

- As with aperture and shutter speed, there are generally ISO values available that fall between the main ISO settings. ISO 125 and 160 are 1/3-stop values between 100 and 200 ISO.

- For maximum image quality use the lowest ISO setting.

- Large sensors typically suffer less from noise at higher ISO settings than smaller sensors.

- If you use a tripod or light-sapping filters such as ND filters, it's better to use a manual, fixed ISO setting.

- Automatic modes on a camera typically lock you out of altering the ISO, forcing you to use Auto ISO.

Above: Cameras can be set to adjust ISO automatically depending on the ambient light levels. This is a useful way to avoid camera shake when handholding a camera, particularly if light levels fluctuate during a shooting session. Auto ISO increased the ISO to 1600 when shooting this image in a dimly lit room. Although the image is noisy, that's preferable to an unsharp image caused by camera shake.

RECIPROCAL RELATIONSHIP

Shutter speed, aperture, and ISO work in what's known as a reciprocal relationship. If you change one control you then have to adjust at least one of the other two in order to maintain the same level of exposure.

Here's an example: your camera meter shows that the correct exposure for a scene is 1/125 sec. at f/16, with an ISO setting of 100. However, you may want to use a larger aperture to minimize depth of field—say, f/5.6. The difference between f/16 and f/5.6 is three stops (f/16 > f/11 > f/8 > f/5.6). If you adjusted the aperture only, the image would be overexposed by three stops.

To maintain the same level of exposure you could lower the ISO. However, 100 ISO is typically the lowest ISO on a camera. The only other control that can be altered is the shutter speed. In this instance, the shutter speed needs to be made faster—allowing less light to reach the sensor to compensate for the fact that the aperture has been made wider. The shutter speed also needs to be adjusted by three stops to 1/1000 sec. (1/125 sec. > 1/250 sec.> 1/500 sec.> 1/1000 sec.).

There may be occasions when a particular setting can't be used without over- or underexposure. The shutter speed range is far larger than the range of available apertures on a lens. Problems often occur when you want to shoot using shutter speeds at the extreme end of the range: when shooting using a fast shutter speed you can't open up the aperture as wide as necessary, or when shooting using a slow shutter speed you can't close the aperture down far enough.

The solution to the first problem is to increase the ISO setting or, if possible, shoot under more powerful lighting. The solution to the second problem is to use ND filters or to work under less powerful lighting. In the end, you select the combination of shutter speed, aperture, and ISO for pragmatic reasons (do you want to avoid camera shake?) or for aesthetic reasons (do you need front-to-back sharpness in an image?).

Left: This photo was shot using an aperture of f/11 and a shutter speed of 1/15 sec. at 100 ISO. However, they weren't the only exposure settings I could have used to achieve the same level of exposure. In this case, I chose f/11 to ensure front-to-back sharpness. The shutter speed was irrelevant as the camera was mounted on a tripod. The table below shows other combinations I could have used.

APERTURE (F STOPS):				
f/5.6	f/8	f/11	f/16	f/22
SHUTTER SPEED:				
1/60	1/30	1/15	1/8	1/4

DYNAMIC RANGE

Sensor technology improves year on year. However, camera sensors have their limitations. One of these limitations is dynamic range. When we look at a scene—unless contrast is particularly high—we are generally able to see detail in both the highlights and the shadows.

Use a camera and you often find that you can set the exposure to record detail in the highlights or the shadows but not necessarily both at the same time. The greater the difference in brightness between the highlights and the shadows, the more difficult it becomes to preserve both in a single exposure. The range of brightness levels a camera can successfully record is known as its dynamic range. Typically, cameras with large sensors have greater dynamic range than those with smaller sensors.

Overexposed highlights result in pure white pixels. Underexposed shadows result in pure black pixels. In both cases there is no useable image data in those pixels—the data is said to be "clipped". No matter how much you lighten or darken a picture afterwards you'll never be able to recover this lost image data.

By its very nature, black and white photography requires image adjustments in postproduction. It's easier to achieve the desired effect in postproduction if your image initially has a full range of usable tones without loss at either end (ultimately you may want your shadows black and your highlights white, but you don't want to preclude other options right from the start).

It's a good exercise to experiment with your camera to determine its dynamic range. Getting to know your camera this way will make it easier to make informed decisions about exposure later. If you decide that your camera has a small dynamic range, you'll be more aware of potentially problematic scenes before you begin shooting and whether you need to take remedial action.

NOTE

High-contrast scenes are the biggest test of a camera's dynamic range. The key to high contrast is finding a way to lower it. For relatively small subjects that can be achieved by using a reflector to "bounce" light back into the shadows. Another method is to use extra lighting—such as flash—to fill in the shadows. Larger subjects are more problematic and either require several additional lights or, if the subject is outside, waiting until the sun has been obscured by cloud or moved so that your subject is in shadow.

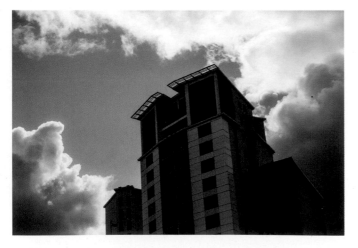

Above: This type of scene—the subject in shadow and bright highlights in the background—is a good test of a camera's dynamic range. Recovering shadow detail is easier with my camera than recovering highlight details, so in this instance I exposed to retain highlight detail and lightened the front of the building in postproduction.

HISTOGRAMS

A histogram is a graph showing the distribution of tones or brightness levels in an image. From left to right, the horizontal axis shows the tones from pure black (with an RGB value of 0, 0, 0) through to pure white (with an RGB value of 255, 255, 255). In the middle of the histogram are the mid-tones. The vertical axis shows how many pixels of a particular tone are present in the image—the higher the bar, the more pixels there are of that tone.

If image data is "clipped" the histogram will show either a single bar at the clipped end of the tonal range, or the histogram will appear to "lean" against the right or left edge of the histogram box. Bright lights will often clip the "highlight" end of the histogram, although this is generally acceptable—you'd have to seriously underexpose the rest of the image to stop the lights from clipping. Otherwise, it's normally advisable to prevent the histogram from clipping either end, if possible.

Histograms can be viewed in image playback and even, depending on the camera, in Live View on the LCD screen. For an "average" scene, if the histogram is biased to the right, and the highlight end of the histogram is clipped, you'd need to apply negative compensation—darkening the image. If the histogram is biased to the left and the shadows are clipped, you'd apply positive compensation—lightening the image.

Histograms are an excellent, and objective, method of assessing the exposure of an image so that you can take action if the exposure is incorrect.

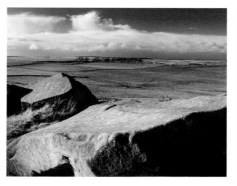

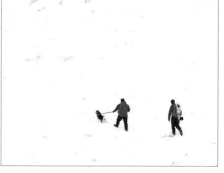

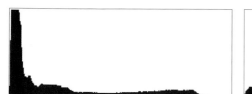

Above: The shape of a histogram is determined by the range of tones in an image. This image is dominated by dark tones, with a few mid-tones and no bright highlights (it's therefore not an "average" scene). The histogram is skewed to the left, but in this instance this doesn't indicate underexposure.

Above: The tonal range of this image is more evenly spread across the histogram. This is a more typically shaped histogram compared to the previous image.

Above: This image is dominated by light tones, with a few mid-tones (the people) and no shadows. Like the first image, it's not an "average" scene. The histogram is skewed to the right, but this doesn't indicate overexposure in this instance.

PART TWO
LIGHT & COLOR

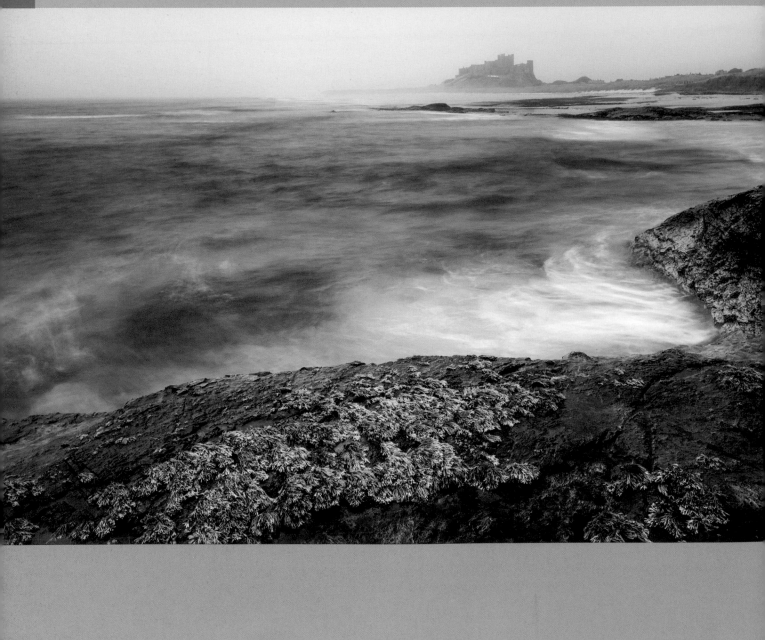

There are two factors that can make or mar a photograph: the quality of the light that illuminates your subject and how your subject is framed within the image space.

A successful photographic image doesn't happen by accident. As automated as modern cameras are, it's the responsibility of the photographer to make an image. The first requirement is that a photo needs to be technically "correct". An accidentally out-of-focus or incorrectly exposed image is an immediate candidate for the trash can. Note, however, that "correct" could also mean that an image is deliberately out of focus or "incorrectly" exposed to achieve the desired effect.

Just because an image is technically perfect doesn't mean that it will capture anyone's imagination. What sets a great photograph apart from a mediocre one are two things. Firstly, how light falls on the scene in front of the camera and whether this improves or detracts from the image. And secondly, and just as importantly, whether the various elements in the image, including the subjects and their surroundings, have been composed in an aesthetically pleasing or arresting manner.

This section is about these two very important aspects of photography: light and composition. To progress as a photographer—whether you shoot in color or in black and white—you have to be willing to learn about both. Fortunately, learning about composition and light is addictive. Once the interest takes hold, you'll find you'll continue to want to learn. And, it's something you can do without a camera, whenever you have a spare moment, by looking out of a nearby window or on the walk to work or college. The only frustration is that you won't have a permanent record of your observations—which is perhaps a good incentive to have a camera with you at all times.

Above: How light falls on your subject defines how three-dimensional the subject will look in the final image. This is important when shooting black and white images as there are no color cues to help define shape.

Left: A satisfying composition can take time to find—it's not a task that should be rushed. This shot took almost 10 minutes to work out before I was satisfied with the composition. Most of this time was taken up by swapping between lenses and altering my position relative to the foreground until I had a "eureka" moment.

COLOR

It may seem obvious, but you need light to make a photograph. However, the success or otherwise of an image depends on the quality of the light you shoot with. Light has many qualities which are explored in this Lesson.

WHITE BALANCE

Visible light is a range of wavelengths that correspond to the spectrum of colors from red through to violet. Light is neutral when there is an even mix of wavelengths. However, if a range of wavelengths predominates then the color of the light is biased towards those wavelengths. A good example of this is an incandescent bulb, which is heavily biased towards red. We don't see this bias easily as our brain normalizes the color of the light.

A camera is an objective recording device. Without correction, images shot under an incandescent bulb would be tinted red or orange. Fortunately, cameras have a function known as white balance (WB), which allows you to correct for color bias. The simplest way to achieve this is to use Auto WB. In this mode the camera automatically adjusts the white balance without intervention from the photographer. A more precise way to adjust WB is to use one of the camera's WB presets. You set the correct preset to match the type of light you shoot with. A grid below shows the presets and their symbols commonly found on cameras.

You'd be forgiven for wondering what the color of light has to do with black and white photography. Counter-intuitively, setting the correct white balance is very important if you intend to convert a color image to black and white post-shooting. The colors in the image need to be as pure and representative as possible. An image that's heavily biased towards a particular color will make it more difficult to separate the various tones in the image during the black and white conversion process.

> **NOTE**
>
> When shooting Raw you can adjust the white balance in postproduction. If shooting JPEG you need to set the correct white balance before shooting.

NOTES	WB PRESET
Domestic lighting	
Fluorescent lighting	
Midday sunlight (summer)	
Electronic flash	
Overcast conditions	
Shade	
Auto white balance	

Right: This sequence of images shows a daylight scene taken with a domestic lighting preset (top left) and a shade preset (bottom left). The images were then both converted to black and white using exactly the same process. The domestic lighting image has lost a lot of detail in the shadows—particularly in the clouds (top right). The shade image is better but it's still not ideal—it looks flat with muddy highlights (bottom right). Ideally, in this instance, a daylight preset should have been used.

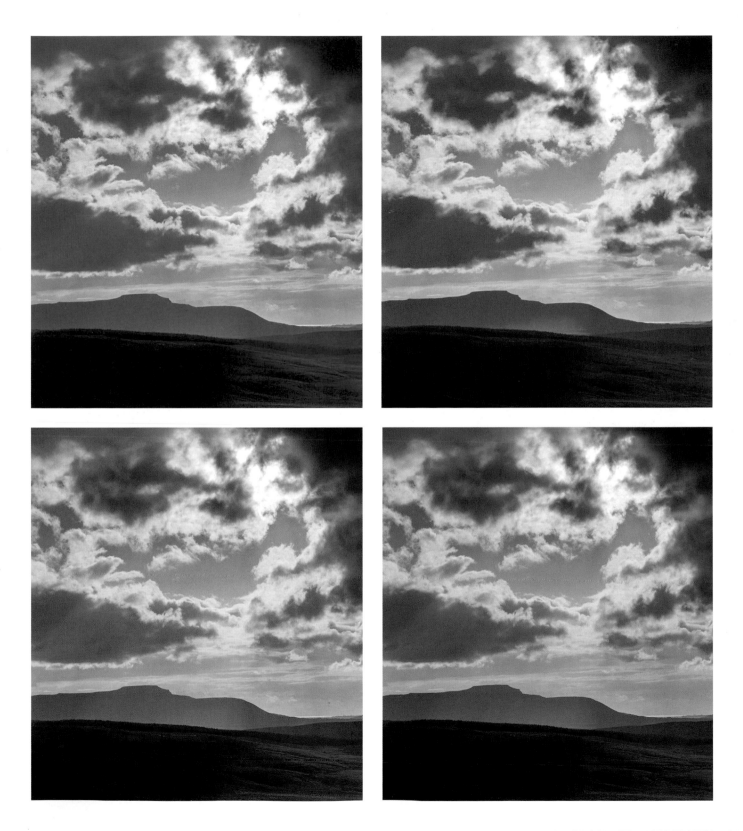

DIRECTION

An important quality of light is its direction. Direction is determined by the angle in which the light falls—relative to the camera—onto the scene in front of the camera. There are essentially four directions in which light can fall: frontal lighting, side-lighting, top-lighting and backlighting. The direction of the light determines where the highlights and shadows fall. Shadows in particular help to reveal form and texture. Without shadows it's more difficult to convey a sense that a photograph represents a three-dimensional subject.

FRONTAL LIGHT

A frontal light is a light source situated behind the camera. As a result, any shadows cast by the light will fall behind the subject out of sight of the camera. Frontal lighting isn't an ideal lighting scheme for this reason—it's not especially flattering and will produce flat-looking images. On-camera flash produces a frontal light, which is why it's advisable to use flash off-camera if possible. Another problem with frontal lighting is that there's a risk that you'll cast a shadow into the scene. This is a particular problem when shooting subjects with a wide-angle lens.

SIDE-LIGHTING

As the name suggests, side-lighting is cast at an angle of roughly 45-125° to the camera. This type of lighting is ideal for revealing the form and texture of your subject, and therefore creating a sense that your subject is three-dimensional. The one problem with side-lighting is that it can create too much contrast. Depending on the hardness of the light (see page 38) you often need to reduce contrast by using additional lighting or a reflector to "fill in" the shadows and reduce their density.

TOP-LIGHTING

Top-lighting falls down onto the scene from above the camera. Although it does reveal form and texture, it's not an ideal lighting scheme. It should be avoided for subjects such as portraits—particularly when it's a hard light—as

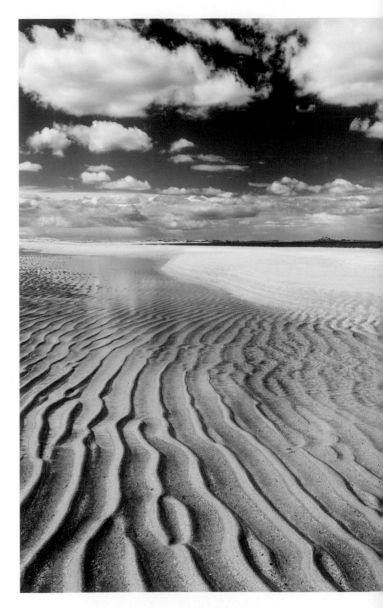

Above: Side-lighting has helped to define the shapes of the ripples in the sand here. If the sun had been higher, or even behind the camera, the shape of the ripples would have been less obvious.

Right: Silhouetted backlit subjects work best when they have a relatively simple and easily discerned outline. Complex shapes work less well as they're not as easily "read", and the person viewing the image will have to work harder to decode it.

shadows are cast below facial features such as the nose and chin—this is especially unflattering!

BACKLIGHTING

Backlighting is caused when the light is behind your subject, pointing directly towards the camera. This produces potential problems with contrast as the side of your subject facing towards the camera will be in shadow. If you expose so that your subject is correctly exposed then the background will be overexposed.

There are two solutions. First, you use additional lighting or a reflector to push light back towards your subject to reduce the contrast. This is a particularly useful technique when shooting portraits. Backlighting produces an attractive rim light as it shines through your subject's hair. Backlighting also ensures that your subject won't be squinting and will be able hold a normal—and hopefully—pleasing expression.

The second solution is to embrace the contrast and shoot your subject as a silhouette. This is more effective when shooting a subject that has a readily identifiable outline. Silhouettes are less easy to read if the subject has a complex outline or if you have several subjects that overlap each other, so that the individual shapes of the subjects can't be discerned. If your camera heavily biases exposure to the focus point you may need to use negative exposure compensation so that your subject is recorded as a silhouette.

Above: You don't need direct light for light to be directional. When shooting this shot, the sun was below the horizon. The brightest part of the scene was the ambient light from the sky above where the sun was due to rise. Shooting in this direction meant that the boulders in the foreground were backlit.

HARD & SOFT LIGHT

Light can also be described in terms of its hardness or softness. Hard light is caused when a light source is small, relative to the subject it is illuminating. Soft light is created when the light source is larger relative to the subject.

Hard light creates bright highlights on your subject (particularly if the subject is shiny) and dense, hard-edged shadows. Good examples of this type of light are the sun in a cloudless sky and flash. Hard light is dramatic and suits subjects that are angular or inorganic. It's not a lighting scheme that's often used in portraiture as it can be too brutal—though this depends on your subject: it can help to accentuate a rugged male face, for instance.

Soft light produces low contrast, with very pale (even non-existent) shadows with attenuated edges. In the natural world, light is soft on overcast or misty days because the light from the sun is diffused across the entire sky—making it a larger light source than normal. Soft light is suitable for organic subjects such as close-ups of flowers or portraiture.

NOTES

- Light from a flashgun fitted to a camera is a hard light source, unless the light is modified using a diffusion screen or reflector.

- Bright highlights on shiny non-metallic surfaces—depending on their angle relative to the camera—can often be reduced by using a polarizing filter.

Left: There's no such thing as good or bad light—just light that's right for your subject. This sculpture required a relatively hard light in order to define the form of the face. Softer shadows would have made the face appear less three-dimensional.

Above: Hard sunlight is best suited to defining the shape of geometric subjects such as architecture.

HIGH- & LOW-KEY LIGHTING

High-key lighting is a technique of using light that ensures that there are few, if any, dark tones in an image. It typically involves using three or more soft light sources. Low-key lighting is the exact opposite, producing images composed of mainly dark tones, with few bright highlights.

High-key lighting results in the subject or scene being brightly but evenly lit, and any potential shadows cast are either lowered in density or removed completely. A common way to achieve a high-key effect is to use one main light (known as a key light), a light for filling in shadows (referred to as the fill light), and a backlight to illuminate the background. High-key lighting is gentle and can be used to convey a romantic or innocent mood in an image. It's commonly used for portraiture, particularly when shooing female subjects or children.

Low-key lighting generally only requires the use of one light (the "key light"), though the effect can be controlled by using a reflector or weak fill light to moderate the density of the shadows. Low-key lighting produces moody, dramatic pictures that are particularly effective in black and white.

NOTES

- A pseudo high- or low-key effect can also be achieved by over- or underexposing an image, respectively. However, this approach is generally less effective than adjusting how your subject is lit.

- Use your camera's histogram (either in Live View or in image playback) to check that the shadows or highlights are "clipping".

Left: Shooting low-key images sometimes involves blocking light. The background to this shot was kept dark by shading it from the light source illuminating the subject.

Right: High-key lighting can help to imbue an image with a romantic feel. The effect has been enhanced by the use of a soft-focus effect achieved by breathing on the lens just before shooting.

METERING

Aim: Shoot a series of nine images of scenes with different levels of reflectivity and at different levels of exposure compensation.

Learning objective: To see how different exposure settings affect the apperance of an image.

Equipment checklist:
• Camera and lens
• Tripod

Brief: Mount your camera on a tripod and set your camera's meter to evaluative (matrix or multi-pattern). Look for scenes with an average reflectivity and shoot a test image. Use the camera's histogram to judge whether the image is correctly exposed. Then apply 1 stop positive exposure compensation and shoot the scene again. Apply 1 stop negative exposure compensation and reshoot. Next, find and shoot two scenes—one with lower-than-average reflectivity, and one with a higher-than-average reflectivity. Shoot these scenes using no exposure compensation followed by 1 stop negative and 1 stop positive exposure compensation. You should have nine images.

A camera meter measures the amount of light reflected from a scene. The meter assumes that the scene has average reflectivity—for example, scenes with green foliage generally have average reflectivity. However, there will be occasions when this isn't the case, so it's useful to be able to recognize when such a scene may cause problems for your camera's metering. Scenes with a higher-than-average reflectivity—such as snow or light-colored sand—often cause underexposure. In contrast, dark scenes will have a lower-than-average reflectivity, and will cause overexposure. The solution is to apply positive exposure compensation to the high-reflectivity scenes and negative exposure compensation to the low-reflectivity scenes.

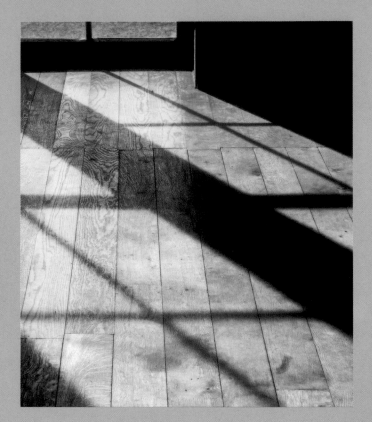

Above: This relatively simple scene was dominated by tones that were paler than a middle gray. As a result, I had to use 1.5 stops of positive compensation to achieve the right exposure.

TIPS

• Evaluative metering is usually the default metering option.

• If your camera has auto exposure bracketing you can use this to apply negative and positive exposure compensation for the second and third images in each scene.

Above: Some cameras heavily bias the exposure to the point where the camera focuses. The focus point in this shot was in a brightly lit patch toward the bottom. Because of this I had to use 0.6 stops of positive compensation to retain some detail in the darkest areas of the image.

ANALYSIS

Once you've shot the sequence of images, copy them to your computer, convert them to black and white (if you didn't shoot in black and white in-camera), and view each one in turn. For this project, the artistic merits of the shots are relatively unimportant.

Above: There's more latitude to correcting exposure problems in post-production when shooting Raw than when shooting JPEG. However, even when shooting Raw you should avoid being more than 2 stops under- or overexposed, if possible. This image (shot on a compact camera) was 1.5 stops underexposed. Correcting this error has resulted in noise being revealed in the darkest areas of the image.

1 What you should be critically assessing is how well the image is exposed. If your software allows it, view the histogram for each image too. This will also be a useful guide to exposure, although remember that there's no perfect histogram shape for exposure.

2 Theoretically, the "average" scene should be correctly exposed. Compare it with the versions of the image that you under- and overexposed. Is the exposure better on either of those two? Exposure can be adjusted for creative reasons, so even though an image may not be technically correctly exposed, it may still work aesthetically. Underexposure will make an image more moody, and overexposure will open up shadows and make an image seem more airy.

3 Compare the three versions of your higher-than-average-reflectivity images. Which, if any, version is correctly exposed, or which is the closest? It should be the image that you overexposed. However, the ambient light levels can make a difference to exposure. Very reflective scenes sometimes require 1.5 to 2 stops of positive compensation.

4 Compare the three versions of your lower-than-average-reflectivity images. As with step three, which, if any, version is correctly exposed? Again, if no image is correctly exposed, which is the closest? This time, it should be the image that you underexposed. Very dark, unreflective scenes—for instance, volcanic rock is often almost black—sometimes require 1.5 to 2 stops of negative compensation.

5 Repeat the project with different scenes so that you become familiar with how your camera's light meter works. Experiment with exposure compensation as you become more confident at assessing a scene.

Above: The average range of tones in this image was actually lighter than a mid-gray. By blurring the image (far left), you can see the tonal range more easily. Compare this to the mid-gray patch (left) to see the difference. As a result, I had to use 1 stop positive compensation to achieve the correct exposure in the shot.

REFINE YOUR TECHNIQUE

Using evaluative metering will generally produce pleasing results. However, using your camera's spot meter (or partial metering mode) will help you obtain greater accuracy. The first skill to be learnt when using a spot meter is assessing whether your metering target is a mid-tone. Subjects like green grass and gray rocks are good examples of subjects that are mid-tones.

- To extend this project further, spend the day using the spot meter exclusively. Meter from different areas of a scene and see how they differ in terms of the exposure. Set the exposure when you feel confident that you've metered from a representative mid-tone. Use the image-review histogram to see how well you've done.

- An important use for spot metering is metering the foreground and sky of a scene, helping you to judge whether an ND grad is needed, and what strength of filter is required to balance the exposure. The easiest method for achieving this is to shoot in manual exposure mode (with ISO set to a fixed value rather than auto). With spot metering selected, meter from a mid-tone in the foreground. Set the required shutter speed and aperture. Next, take a meter reading of the brightest part of the sky in the scene you intend to shoot. Remember, don't meter from the sun or its immediate surroundings—this will be bad for you and your camera! If this meter reading is less than +1.5 stops, you won't need to fit an ND grad. If it's more than +1.5 stops, fit an ND grad that will reduce the difference to +1.5 stops. For example, if the difference is +2.5 stops you'll need to fit a 1-stop ND grad. A very quick and simple way to assess whether an ND grad is necessary is to squint at the scene. If you can no longer see detail in the foreground, then you probably need an ND grad.

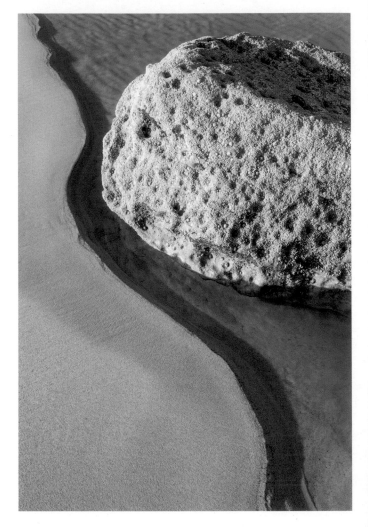

Above: Judging which is the mid-tone to spot meter from takes practice. In this image the far right side of the rock is a mid-tone; the brighter area is lighter than a mid-tone and the shadow area is darker than a mid-tone.

Right: A glossy surface will readily reflect any ambient light that surrounds it. There is no direct light on this foreground. The distinctive shapes are created by the difference in the way that the wet sand is reflecting the light from the clouds above, compared to the drier sand, where no water channels have formed.

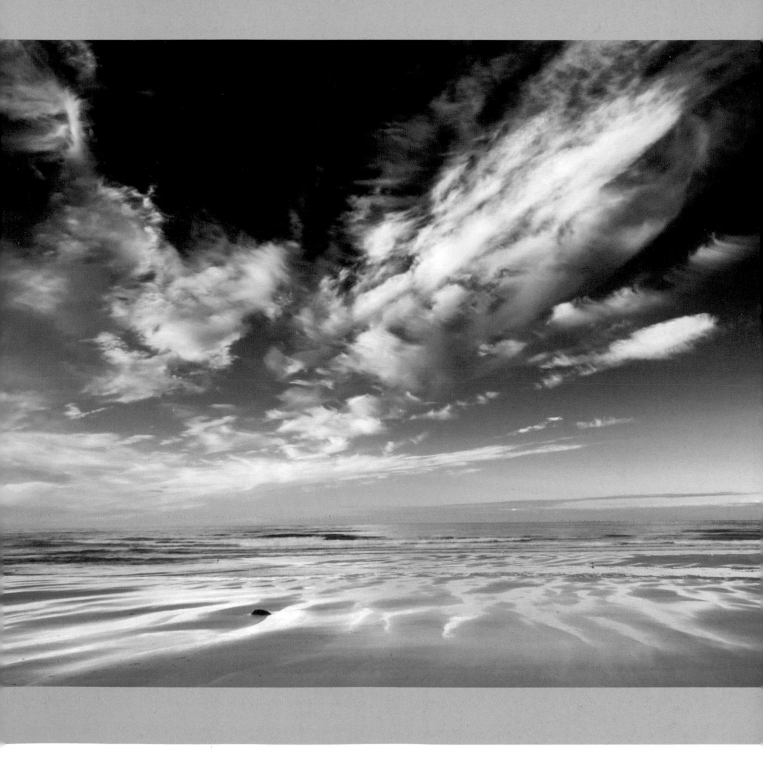

ARRANGING THE ELEMENTS

Photographic composition is the art of arranging the various elements of a scene within the image space in an aesthetically pleasing or unsettling way.

There are various "rules" of composition that provide useful shortcuts to producing a pleasing image and some are described on the following pages. However, it's all too easy to produce formulaic images by following rules too slavishly. With practice, the ability to create a pleasing—and more individual—composition becomes almost instinctive.

It can be inconvenient to carry a camera around with you (unless it's on your cellphone). However, you can practice framing compositions by simply forming a rough square or rectangular shape with your forefingers and thumbs. Bring your hands closer to your eyes and you emulate a wide-angle lens; move them further away and you emulate a telephoto lens. A refinement of this technique is to cut a rectangular hole in a small piece of card, which you can keep in a pocket or bag.

Assessing whether or not a composition has worked is oddly easier when you turn an image upside down. By doing this, you see the image in a more abstract fashion as a series of lines and shapes. Turning your camera upside down to view an image after shooting may seem slightly eccentric, but it is effective.

What you exclude from a composition is almost as important as what you include in one. Before you make an image, run your eyes around the edge of the frame to make sure that there's nothing unnecessary or distracting protruding into the image space. If your camera doesn't show you a 100% view of the image through the viewfinder, carefully review the photograph after shooting and then recompose and reshoot it if necessary.

Left: Bright highlights are very eye-catching. When making this image, I didn't pay enough attention to the edges of the frame. The out-of-focus highlights behind the machine are too distracting and would have been hidden if I'd moved the camera slightly to the left.

Right: Composition is one aspect of photography that can't be automated (though some camera manufacturers have tried). Ultimately, how an image is composed is a very personal decision. Place 10 photographers in a location and you'll invariably get 10 different shots. When you compose a photograph you use your own interests and concerns to make the final decision.

FOCAL POINT

The focal point is the most important element in the image—typically, this would be your subject. It's the central point of interest in the image and the ultimate destination for the eye as it roams around the picture.

An image doesn't necessarily need a focal point—abstract pictures arguably don't need one—but it will make an image seem more complete if there is one. Other elements should not be more visually interesting than the intended focal point—otherwise these elements would become the focal points instead.

Lines and other visual cues are useful additions to an image that help guide the viewer's gaze towards the focal point, although lines should be used carefully—you don't want them guiding the eye away from the focal point. You can also emphasize the focal point using several other methods of composition: restricting depth of field so that only the focal point is in focus—this is easier when shooting with a telephoto lens than with a wide-angle lens; ensuring the focal point is far brighter (or far darker) than its surroundings; or picking a focal point with a different texture from its surroundings.

Below: There are some subjects that are inherently eyecatching (or visually "heavy") and make ideal focal points. People are a good example of a visually heavy subject, particularly people's faces (and, even more specifically, their eyes). Writing or symbols are also visually heavy, though far less so than people. In this shot I've included writing but no faces. The writing has become the focal point, which it would not have been if the people in the shot had been facing towards the camera.

RULE OF THIRDS

Mention the word composition to a non-photographer—and even some photographers—and the first words they're likely to say are "the Rule of Thirds". Everyone starts out as a photographer using this "rule" of composition for the simple reason that it works.

The rule is simple: you divide a picture into nine equal rectangles by imagining two lines dissecting the image vertically and two horizontally. Most cameras with Live View are able to display a grid that does just this, so you don't even need to imagine the lines.

The focal point of the image would then be placed on the intersection of two of the lines. By composing an image in this way, the result is generally far more pleasing and interesting than if the focal point were to be placed centrally or towards the extreme edges on either side of the frame.

NOTE

Another use of the rule is to place strong vertical or horizontal elements so that they run along one of the lines of the grid.

Above: The Rule of Thirds works with any shape of image—even panoramic images. This image was composed so that the fourth motor scooter from the left was on a vertical third.

RULE OF ODDS

This is a simple but effective rule that works on the principle that an odd number of elements (of three or more) in a composition is inherently pleasing—far more so than an even number of elements, which always leaves a picture looking strangely unresolved.

When there's an odd number of elements in a composition, one of those elements will be framed by an equal number on either side. However, this rule is less effective when there are more elements than can be easily and quickly counted—three, five, or seven elements are good; 57 or 93 elements are not.

NOTES

• Think carefully about the spatial relationship between the central element and those elements that surround it. You also need to think about how much space is needed between the these subjects and the edge of the picture space. Too little space around them may make the image seem contrived.

• How you arrange the elements within the image will depend on their relative size. A central subject that's small may look overwhelmed and less important when flanked by much larger elements.

Right: Three is a pleasing number of elements in an image. Cover up the boat in the top right corner. Immediately, the composition seems incomplete and less satisfying.

SYMMETRY

Symmetrical compositions involve a repetition of an element within the image space. The simplest form of symmetry in photographs is created when a subject is reflected in a mirror-like surface.

The most common example of symmetry in nature is the reflection of a scene in a perfectly calm body of water. This is known as bilateral symmetry. To emphasize the nature of a bilateral symmetry you'd typically place the dividing line where the subject ends so that the reflection begins halfway down (or across) the image.

A more subtle type of symmetry is radial symmetry. This occurs when similar elements in an image are repeated in a circular flow around an axis point. The petals of flower heads often display radial symmetry, as do artificial subjects such as the hub caps of car wheels. Radially symmetrical subjects work well when placed centrally in an image, particularly if the image is shot or cropped to a square shape.

Another type of symmetry is known as strip symmetry, which requires a repeating pattern along either a vertical or horizontal line in an image. Naturally occurring subjects that display strip symmetry include the scales and patterns found on lizards and snakes. Artificial subjects such as buildings and textiles can also display strip symmetry.

Symmetrical compositions are inherently pleasing. Their repetitive nature makes them relaxing to look at. However, a symmetrical composition lacks dynamism, so it is easy to become bored with looking at it. Including an element within the picture that breaks the repetition is an easy way to add a point of interest or tension.

Above: Anything that breaks a repetitive pattern will be eyecatching and become the focal point of the image.

Above: Lakes can have a mirror-like quality when the surface is undisturbed by currents of air. I shot this image on a calm day when I knew there'd be little wind and a greater chance of achieving a relatively well-defined reflection.

ORIENTATION & SHAPE

Cameras are usually designed to be held horizontally in our hands—that is, unless you've added a battery grip to your camera, or you're lucky enough to own a high-end professional model. For this reason, it's understandable that most images are shot in horizontal orientation.

This way of composing an image makes sense for shooting landscape scenes—landscapes are often wider than they are tall, and we also tend to sweep our gaze from side to side when looking at a landscape. Of course, not everything you'll shoot will be wider than it is tall. People are generally taller than they are wide, unless they're lying down. Portraits are therefore often shot with the camera held vertically, leading to a confusing tendency for vertical shots to be known as portrait format and horizontal shots as landscape format. However, there's no reason to copy this approach—experimenting with an image's orientation is perfectly valid. Horizontal portraits allow you to show your subject in the context of their surroundings, and vertical landscapes images can be used to emphasize the height of a geographical feature.

Camera sensors tend to be rectangular, although some are square and others are a sort of a rectangular-square. The images you shoot will initially be recorded in a shape that matches the shape of the sensor. However, you don't have to accept this. There's no reason why you cannot crop later on to change the shape of your image, and some cameras have various options for cropping the file but these only apply to JPEGs. The key is to visualize how you'd like the image cropped at the moment of shooting and compose as appropriate. This is made easier if your camera has a grid facility that can be overlaid on the viewfinder or rear LCD screen.

Right: Look for features in the scene in front of you as a guide to how you should orientate your camera. In this shot, the strong horizontal lines in the cloud and across the landscape immediately suggested a horizontal orientation.

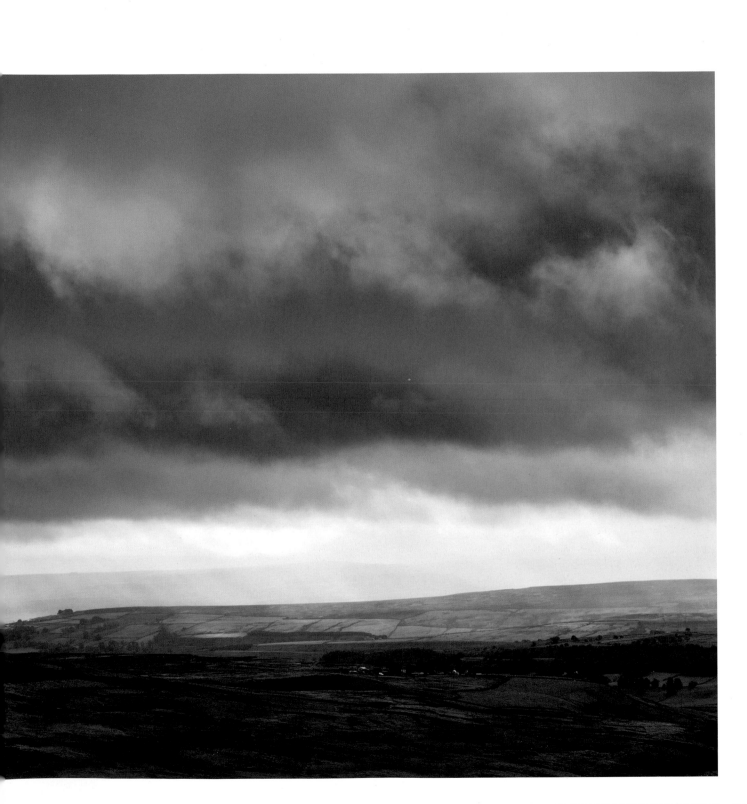

MINIMALISM

There's an understandable temptation to include as much in an image as possible. However, this can lead to confusing pictures in which it's impossible to discern order or sense. A simple composition of just one or two elements often has greater visual impact and allows an image to be "read" quickly and easily with one glance.

Minimalism takes this concept to its logical conclusion by reducing visual information to a bare minimum, to reveal the otherwise hidden essence of your subject. This means excluding anything and everything that is not relevant or could be argued to visually detract from the subject. Black and white photography is, by definition, more minimalist than color, as color can be very visually distracting.

Minimalism can be achieved in a number of different ways. The lens you choose is an important factor. Telephoto lenses are ideal for shooting minimalist images. Their narrow angle of view immediately helps to simplify a composition—wide-angle lenses make it far more difficult to exclude unwanted details.

Another method of simplification is the use of very long shutter speeds—from a second onwards—to blur movement and so soften and obscure detail. The longer the shutter speed, the more effective this method is—ND filters are therefore a useful tool when creating minimalist imagery. Using large apertures to restrict depth of field is another effective way of simplifying a composition.

TIP

High- or low-key exposure helps to simplify an image, too.

Above: Atmospheric haze helps to simplify landscape images by reducing fine detail in the distance. The use of a telephoto lens increases the effect still further.

Right: Soft, shadowless light is perfect for shooting in a minimalist way. This image was made on a misty day when there was no detail in the sky. The use of a 10-stop ND filter allowed me to set a 30-second exposure, which has blurred the movement of the waves washing around the rocks in the foreground.

ABSTRACTION

Cameras record exactly what is put in front of them. This, in the eyes of some people, makes them no better than photocopiers, but this is largely unjustified. It's possible to create strikingly abstract and imaginative images that could be made no other way than with a camera.

By using telephoto lenses, it's possible to shoot details and textures that would otherwise go unnoticed. Restrict depth of field through the use of a large aperture and you can also selectively blur and soften details in an aesthetically pleasing way. The use of long shutter speeds blurs movement, which will also aid in the creation of abstract images. Foliage blowing in the wind or water flowing across a landscape will look more ethereal through the use of long shutter speeds. Asking your portrait subject to move during an exposure can also produce interesting results.

Below: This shot uses repetition for its compositional strength. It appears that the repetition continues beyond the image space, as there's no visual clue that the pattern ends within the image itself.

Left: This abstract image was created by shooting streetlights through a window which was wet with condensation. The required shutter speed was 13 seconds. During that time I slowly rotated the camera to produce the swirling effect.

PERSPECTIVE

Aim: Shoot a series of images with a lens at different focal lengths.

Learning objective: To learn how using different focal lengths changes the perspective in a shot and the relationship between the subject and the background.

Equipment checklist:
• Camera
• A standard zoom or a series of prime lenses that cover a wide-angle to short telephoto range
• Tripod

Brief: Mount your camera on a tripod and set your zoom lens to its widest angle, or fit your widest prime lens. Compose a photo with a distinctive subject, such as a tree, so that it fills roughly half the image—pick a subject that allows you to easily and safely move back from it. Without moving the camera's position, shoot a series of shots, altering the focal length of the lens between each shot. Zoom lenses usually indicate standard focal lengths on the lens barrel (such as 28, 35, 50, and 70mm). Shoot your first image with the zoom at its widest focal length. Then, move the zoom ring to the next marked focal length and shoot the next shot. Repeat until you've reached the longest focal length on the lens. If you're using a series of prime lenses, swap lenses between each shot, starting with your widest lens and working your way through to the longest lens. Next, set your lens back to its widest setting—or use the widest-angle prime lens—so that you return to your original composition. Repeat the exercise above, again altering the focal length of the lens as you shoot. This time, however, move your camera so that your subject stays roughly the same size in the image as you change focal length. To achieve this you'll need to move backwards as the focal length of the lens increases. Convert your images to black and white when you're finished, if they weren't shot in black and white initially.

The term perspective is used to describe the spatial relationships of the various elements in an image. This includes aspects such as the apparent distance between, and change in relative size of, the various elements in an image. This is affected by where you stand in relation to a scene, which in turn is influenced by the lens you use. A simple example of this is when you have one subject and a background. A wide-angle lens invariably requires you to get close to your subject, otherwise it will be relatively small in the frame. A telephoto lens forces you to move back from the subject in order to frame it in a similar way. It's this physical movement relative to the subject that alters the perspective of the image.

TIPS

• Choose a subject that isn't likely to move as you work on this project.

• The greater the range of your zoom lens, the further you'll need to move back from your subject. Ensure that you have room to move back safely.

• Focus precisely on your subject. Depth of field (see page 24) is relatively unimportant, so prioritize shutter speed over aperture, choosing shutter speeds that are most likely to eliminate camera shake. You may need to use a faster shutter speed when using lenses with longer focal lengths.

• Use Live View with grid lines enabled on your camera to help you compose your shots more precisely.

Right: This image was shot with a telephoto lens. This helped to reduce the apparent distance between the lifebelt in the foreground and the cloud curling behind.

ANALYSIS

After you've shot your series of images, print them out so that they're all the same size. Gather the images from the first part of the project together and view them side-by-side. Alternatively, if you don't have a printer, view the images side-by-side onscreen at the same magnification.

Above: A telephoto lens was necessary for this shot so that the four signboards appeared relatively close together spatially. If I'd used a wide-angle lens, the furthest signs would have been far smaller in the frame.

1 Take your time to study these images carefully, noting the effect of changing the focal length of the lens on the size of your subject in the image.

2 Next, gather the images together from the second part of the project and study these carefully. If you've composed the shots correctly, your chosen subject should be the same size in all the images. However, there should be big difference in the spatial relationship between the subject and the background. The background in the image shot with the lens set to its widest setting should appear much further away, and also smaller relative to your subject than in the final image shot with the lens set to its longest setting.

3 After studying the images from the second part of the project, decide which ones you prefer. There's no right or wrong answer to this—it's purely subjective. If you have a much greater preference for one image over the other, consider why this should be, thinking particularly about the differences you noted above.

4 One factor that may be important is the spatial relationship between the subject and the foreground. If your preference is for the wide-angle image, is this because the background is diminished in size compared to the subject? Does the subject have a greater impact visually because of this? If your preference is for the image shot with the telephoto lens, is it because of the way the subject appears to connect more with the background?

5 Compare and contrast the images shot in the first part of the project and the second. Note how a change in focal length can be used to allow you to zoom in or out of a subject as well as change the spatial relationship between your subject and the background.

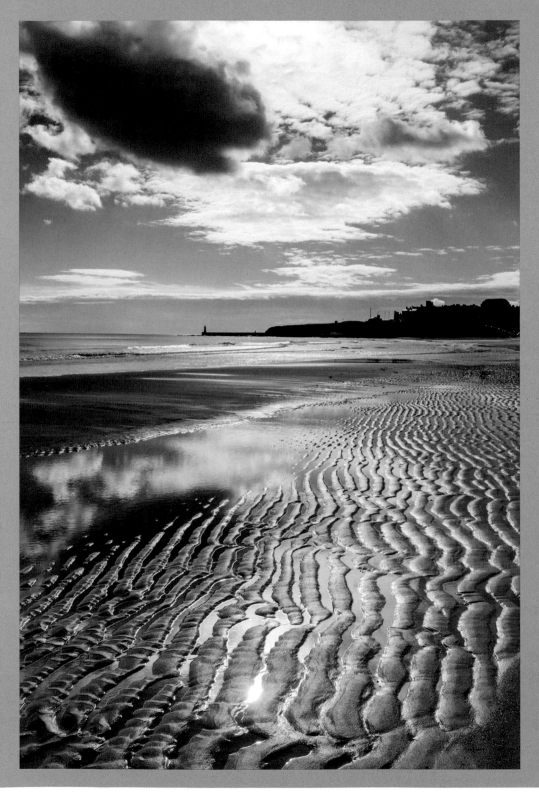

Left: Lines are a powerful way to lead the eye through an image. To create this shot I set up the camera low to the ground and used a wide-angle lens. This helped to fill the foreground with the lines of sand pointing towards the buildings on the horizon. If I'd used a longer lens (and stepped back), the lines wouldn't have converged so dramatically in the distance.

REFINE YOUR TECHNIQUE

Some subjects do not lend themselves to being photographed close-up with a wide-angle lens—the resulting perspective would look unnatural. Portraits are a good example of this type of subject (portraiture is covered in more detail on page 132).

- It's worth taking time to shoot a close-up portrait with a wide-angle lens and a willing subject (your subject should be prepared for an unflattering result). If you really want to push the results to the extreme, try using a fisheye lens, if you have one. You'll need to stand extremely close to your subject—potentially within a few inches—so they'll need to be comfortable with their personal space being encroached upon. Wide-angle lenses are more typically used to shoot environmental subjects that show them in the context of their surroundings.

- The chief visual characteristic of a telephoto lens is the way that distances appear compressed. This can be used to imply intimacy between the various elements in the image. This compression of distance is often used in sports photography to make competitors in race events appear closer together than was actually the case, which adds greater tension to the photo. Using a wide-angle lens would make the competitors appear further apart, which would result in a far less dramatic image and would be unlikely to pique a viewer's interest.

Left: The longer the focal length of the lens the greater the apparent compression of space—and the further you'll need to stand back from your subject. This image was shot with a 200mm lens on a full-frame camera. A similar effect could be achieved with 135mm lens on an APS-C camera or with a 100mm lens on a Four Thirds camera.

Right: Distant objects will appear far smaller than expected when shooting with a wide-angle lens. The key to using a wide-angle lens successfully is to think primarily about the foreground. Only objects in the foreground—assuming you're relatively close to them when you compose your shot—will appear at a reasonable size in the final image.

PART THREE
WORKING IN BLACK & WHITE

There's more to producing a black and white image than simply working without color. This section of the book looks at the decisions you need to make at the time of exposure as well as those in postproduction.

Cameras typically have a range of shooting modes. The simplest of these are the automatic modes such as "landscape" or "portrait". Your camera may also be equipped with effects modes which often include options for shooting black and white images. These automatic and effects modes are a gentle introduction to the world of photography as the camera does much of the work for you—all you have to do is point the camera and press the shutter button. However, in these modes you're generally locked out of adjusting settings—such as white balance and exposure compensation—that allow you to be creative. You may also be unable to switch to shooting Raw (see page 70).

To truly take control of your camera, it's better to use one of these modes: program, aperture-priority, shutter-priority, or manual. Program (P) is an automatic exposure mode in which the camera selects both the aperture and shutter speed, although the exposure decisions can be overridden by you. You are also free to set options such as white balance. Think of this mode as a bridge between fully

automatic and manual exposure control. Aperture-priority (A) and shutter-priority (S) are both semi-automatic modes. In aperture-priority you select the desired aperture and the camera sets the shutter speed, and in shutter-priority you choose the shutter speed and the camera selects the required aperture. Finally, manual (M) mode means that you have to set both the aperture and the shutter speed independently, using the camera's metering as a guide. If you get the exposure wrong it's your fault, not the camera's.

Above: Using either aperture-priority or shutter-priority is highly recommended. Aperture-priority gives greater control over depth of field, which was necessary to create this shot. Shutter-priority gives you control over how movement is captured in your images. If I were a full-time sports or street photographer, it's the mode I would use most often.

Left: The effects modes on cameras are fun to use but are generally limited in what options they give you. There's greater potential for producing exactly the desired effect starting with a "standard" shot and then working on it in postproduction.

FILE CHOICE

There are two ways to create digital black and white images: either shoot in black and white in-camera or shoot a color image and convert it to black and white in postproduction. Odd though it may sound, this second option is the recommended approach.

System cameras offer you the choice of shooting in either JPEG or Raw format (compact cameras and cellphones typically only shoot JPEG). At first glance, JPEG looks the more appealing of the two—JPEG images take up far less room on a memory card, often half that of an equivalent Raw image—and the images are also ready to use immediately after shooting. JPEG files can be used with virtually any application that supports image files, for instance for posting on the Internet. By comparison, Raw files can only be viewed and adjusted using specialist conversion software, and even then the images need to be exported as a JPEG or TIFF file so that the image can be used easily elsewhere. Shoot Raw and you'll need to spend time tweaking the files to get them to a satisfactory and useable state.

Most cameras have a black and white or "monochrome" mode. This allows you to shoot and view black and white images on your camera's LCD. The big difference is that, in Raw, this black and white setting can be unpicked and altered in postproduction. All of the color data is retained by the Raw file so you're not committing yourself to black and white at the time of shooting. This is not the case with JPEG—shoot in black and white and you have a black and white image for ever after, unless you're prepared to hand-color the file later... Raw gives you the flexibility to choose whether you want to switch back to color or even adjust exactly how the colors are converted to black and white. This is an important part of producing a satisfactory black and white image, as we'll see later on.

NOTES

- Cameras have picture controls that allow you to adjust the style of your images. These affect aspects of the image such as contrast, color saturation and, most importantly, whether an image is shot in black and white. Shooting in Raw with your camera's picture control set to black and white is an excellent way to preview what your final image will look like, with the safety net of retaining the color information within the Raw file.

- Some cameras' picture controls allow you to mimic the use of colored filters when shooting black and white. The effects of these filters are covered later in this Lesson (see page 74).

- JPEG file sizes are smaller than Raw files because the image data in the JPEG has been compressed. This compression works by discarding image data. This is generally not noticeable as long as the compression isn't too heavy. Raw files retain all of the image data created by the sensor at the time of shooting.

Right: Shooting Raw when traveling means running the risk of running out of memory card space. In many ways, this is no bad thing. If shooting is strictly rationed you're more likely to make every image count. It's a way of thinking that can also be applied when shooting closer to home.

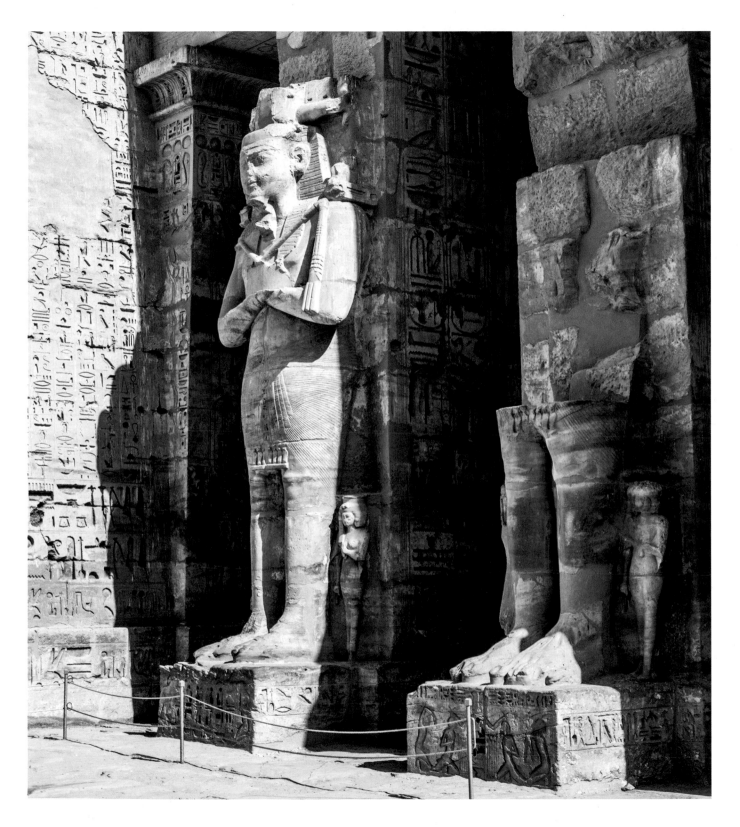

BITS & BYTES

Although you may think you're manipulating color and details when you adjust an image in postproduction, you're actually changing numerical data. The smallest unit of data used by a computer is a bit. A bit is essentially a switch that can be set either off or on. When a bit is off this represents a value of zero; when the bit is on this represents the number one. This simple on/off system allows the computer to count using a system known as binary. Eight bits together become a byte. A byte is able to store numerical values from 0 through to 255 in binary.

This range of 256 numbers is the perfect size to represent a series of grayscale values from black (0) through to white (255), with a mid-gray at 127. However, the world would be a dull place if monitors could only display shades of gray. Three bytes are used to create a color pixel on a monitor: one byte for red, one for blue, and one for green (which is why monitors are known as RGB displays). By varying the values assigned to each RGB byte it's possible to create and display over 16 million different colors. As an example, a deep orange is displayed when the red byte is set to 255, the green byte to 127, and the blue byte set to 0.

Although 256 separate values may seem a lot, it's actually not enough if the data in an image needs to be heavily modified in postproduction. As you modify an image, the postproduction software performs a series of calculations on that data. The more the data is modified, the greater the number of rounding errors that start to creep into the calculations. This is seen as "posterization" in an image, which is when colors no longer look true

and there are sudden shifts in tone rather than smooth gradations. JPEG images use the 8-bit model, which is why it's so difficult to heavily edit a JPEG image without serious loss of image quality. Raw files typically use 12, 14, or 16 bits to record color information. Although this information can't be displayed onscreen (monitors are 8-bit devices) postproduction software can use this information to keep image data true as the image is adjusted.

Above: This image shows extreme levels of posterization. Note how the tonal transitions are abrupt, particularly in the clouds and in the sea.

THINKING IN BLACK & WHITE

The most important difference between a color and a black and white image is that there's no color in the black and white image. Although this may sound obvious, it does mean that you have to learn how to think differently when shooting in black and white.

We see in color and react to color cues in the world at a very deep level. Colored lighting can affect mood in a very striking way—for instance, cool blue light is far less comforting than warm orange light. Color can be used to evoke emotional responses in a photograph too. It can also help to define the shape and allow easy identification of different elements.

All of these visual cues are missing from a black and white image. A black and white photograph is composed of a range of tones, typically a neutral gray—though tinting will add color back, albeit in a monochromatic way. As the phrase "black and white" suggests, this range of tones can stretch from black through to white.

However, a black and white image doesn't necessarily need to feature either of these two extremes. A flat, low-contrast black and white picture would be mainly composed of a narrow range of gray tones. Controlling the range of tones in an image to produce the desired effect is the key to success. This is partly achieved at the shooting stage: how you use light will determine the contrast or otherwise of your images. It's also dependent on how colors are converted to black and white either in-camera or in postproduction.

Above: High contrast in a scene is usually a reliable indication that the resulting image will work well in black and white. In this image, the contrast is due to the way the light has backlit the translucent fern but is not illuminating the background.

COLOR TO BLACK & WHITE

The tonal value of an object in a black and white image depends on its reflectivity. An averagely reflective subject in a color image—green grass, for example—will be a mid-gray when that image is converted to black and white.

The less light a subject reflects, the darker it will appear in the image, and the more light it reflects, the lighter it will seem. However, there's a problem if two or more objects in a scene are colored differently but have the same basic reflectivity. In a color image the various objects are easily distinguished. Convert the image to black and white and the objects will all have the same tonal value. Visually, this isn't ideal and can lead to flat-looking images with a narrow tonal range.

The solution is to use colored filters. A colored filter blocks the wavelengths of light on the opposite side of the standard color wheel to the color of the filter—see below. Look at the red segment; opposite it is the green-blue segment. If you were to shoot an averagely-reflective green-blue object in black and white through a red filter, the object would darken so that it becomes darker than a mid-tone. Not only that, but if you were to shoot an averagely-reflective red object through a red filter it would actually lighten. In this way, filters can be used very effectively to change the tonal relationships of objects in a scene so that there is a very marked difference in the final image.

With digital photography, there is no need to use physical filters, although they are necessary when shooting with black and white film. Many cameras allow you to simulate the effects of using a filter when shooting in black and white, whether using JPEG or Raw. Typically, the range of filter effects includes yellow, orange, red, and green.

FILTER	PORTRAITURE	LANDSCAPE
Yellow	Lightens skin tones	Gently darkens blue sky
Orange	Reduces appearance of freckles	Darkens blue sky
Red	Skin tones washed out	Darkens blue sky dramatically. Effects of mist and haze reduced
Green	Skin tones darkened	Lightens green foliage. Weakly lightens sky. Darkens red/orange flowers
Blue	Skin tones darkened unnaturally	Sky definition lost. Enhances effect of mist and haze

NOTE

Converting an image to black and white in postproduction will give you even greater flexibility in how the colors are converted to black and white. See page 78 for more information.

Above: The color wheel is a useful tool for judging the effects of filtration, whether you use physical filters, virtual filters in-camera, or alter the image during postproduction.

Below: Filters can have a dramatic effect on how a color image is rendered in black and white. This diagram shows the effects of the most common colored filters on the spectrum of colors (also see the next page).

Colors

Simple desaturation

Yellow filter

Orange filter

Red filter

Green filter

Blue filter

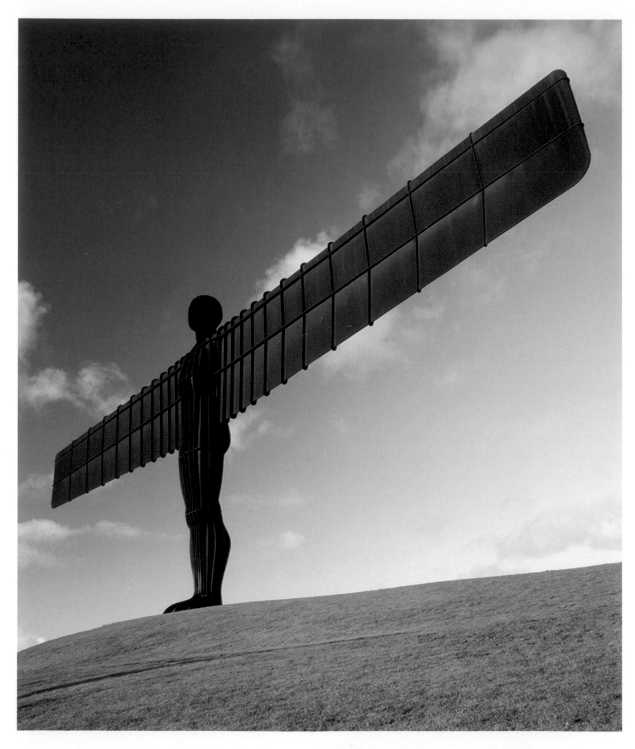

Above: The original color image contained red-orange, green, and blue—all at roughly the same brightness level.

Above: The original color image has been converted on the computer using the default black and white conversion process, resulting in an even-toned but flat-looking image.

Above: Converted with a red filter emulation, the blue of the sky appears a much deeper shade, with the result that the statue stands out well, giving the image impact.

Above: Less successful is the use of a green filter. As with the simple default conversion, the tonal range is similar and the image looks flatter as a result.

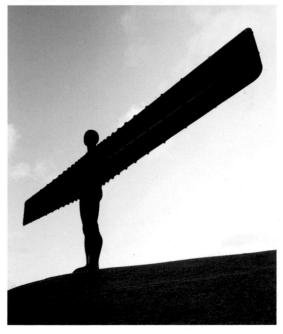

Above: Least successful of all is the use of a blue filter. This has caused the sky to lighten considerably and definition has been lost on the statue itself.

CONVERSION TOOLS

There are a number of ways to convert a color image to black and white using postproduction software—although some are better than others. Adobe Lightroom has been used as the example software in this book. However, the principles described apply to most postproduction software currently available.

DESATURATION

The simplest and quickest way to remove color from an image is to remove the saturation of the colors in the image. In Lightroom, this is achieved by dragging the Saturation slider on the Presence panel down to -100. Although this produces a black and white image, the results are generally unsatisfactory. There is no way to control how colors are converted to black and white, so it's impossible to separate colors tonally if this is required.

NOTES

- All the Lightroom techniques described here use tools found in Lightroom's Develop module.

- Camera Raw is a plug-in used by Adobe Photoshop and Photoshop Elements, and allows you to import Raw files into the software. Camera Raw shares most of the tools found in Lightroom. Most of what is described here is therefore applicable.

- Lightroom is supplied with a number of Presets that automate many of the conversion tasks. There are, for example, a number of Presets that emulate the use of colored filters and these can save a lot of time if you've numerous images to convert.

BLACK & WHITE

A better option, with more control over the conversion process, is the Black & White button found on the Basic panel. Clicking on this button converts the image to black and white and allows the use of the Black & White Mix sliders found on the HSL / Color / B&W panel.

The various sliders show the basic spectrum of colors, starting with red and ending with magenta. If you a move a color slider to the right (so that it has a positive value) you lighten the tones in your converted image that correspond to that color in the original image. Alternatively, if you move the slider to the left (so that it has a negative value) you darken the tones in your converted image that correspond to that color.

By adjusting the various sliders you can very effectively separate the different tones in the image in much the same way as using filters, as described previously. To emulate the use of a red filter, you'd move the red slider to the right and the blue slider to the left (lightening reds in the original color image and darkening blues), and so on.

Achieving a satisfying black and white conversion is often a process of experimentation until you have the desired effect.

OTHER ADJUSTMENTS

Converting an image to black and white isn't the end of the story. Images (particularly Raw) often need refining further. There are two ways to adjust an image: either globally, so that the entire image is affected, or locally, so that you adjust only small areas as necessary.

EXPOSURE

Postproduction software will allow you to adjust the exposure of your image—making it either lighter or darker. This is done in much the same way as would happen if you'd applied exposure compensation at the time of shooting. Minor exposure correction is useful, although you should be careful about pushing the process too far. Depending on the dynamic range of your camera, there may not be much latitude for adjustment without serious loss of image quality. Typically, darkening a picture is less destructive than lightening it, as lightening an image will reveal noise in the shadows.

CONTRAST

Raw files can often look flat and lack contrast, though this will depend on the picture control chosen at the time of shooting. Contrast defines how far apart—tonally—the darkest and the lightest pixel in an image are. If an image were adjusted so that contrast were at maximum, pixels in the image would either be black or white—there wouldn't be any intermediate gray pixels at all. The brightness of the pixels in the shadows and the highlights in a low-contrast image would be, if not identical, very close in value to each other. The contrast in most images will be somewhere between these two extremes. Generally, adding greater contrast to an image will make it look punchier and add impact. However, not all images need this and sometimes subtlety is more appropriate

High contrast

Normal contrast

Low contrast

SEEING IN BLACK & WHITE

Aim: To shoot an image and convert it in postproduction editing in order to generate six black and white versions, simulating the range of color filters.

Learning objective: To discover the effects of using different postproduction filters on a color image, and as a result to be able to predict these effects when shooting.

Equipment checklist:
• Camera and lens
• Tripod (optional)
• Postproduction software

Brief: Shoot a color image that contains objects that have a wide range of colors—the wider the range the better (try to at least include objects that are red, green, and blue). Shoot Raw to maximize image quality or set your JPEG picture control to a neutral color setting so that color saturation and contrast aren't too high. Import the image into your postproduction software. Convert the image to black and white by simply removing the color using the Saturation slider. Save this image using a unique filename that indicates how you've converted the image (such as adding "desat" to the front of the original filename).

Undo the history of changes to the image so that you revert to your original color image. Convert to black and white this time simulating the use of a yellow filter by altering the Black & White Mix sliders as described on page 78 (or use a yellow filter preset if your software has one). Save this image with a unique filename that again indicates how the image has been converted. Repeat this process, simulating using orange, red, green, and blue filters, until you have six black and white images.

TIPS

• A full set of pool or snooker balls would be a good subject for this exercise.

• You can shoot black and white JPEGs in-camera so that there is no need for postproduction editing, if that's preferable. If you work in this way, shoot several images of your subject and fit yellow, orange, red, and green filters in turn, or use your camera's virtual filter picture control. Mount your camera on a tripod so that the composition remains consistent between each shot. Shoot a color version of the shot too.

• Blue filters are rarely used for black and white photography. They aren't generally an in-camera option, though it's possible to mimic their effects in postproduction.

Left: It can be difficult to find natural subjects that display a wide range of colors. For this project architectural or a specially created still life scene will work best.

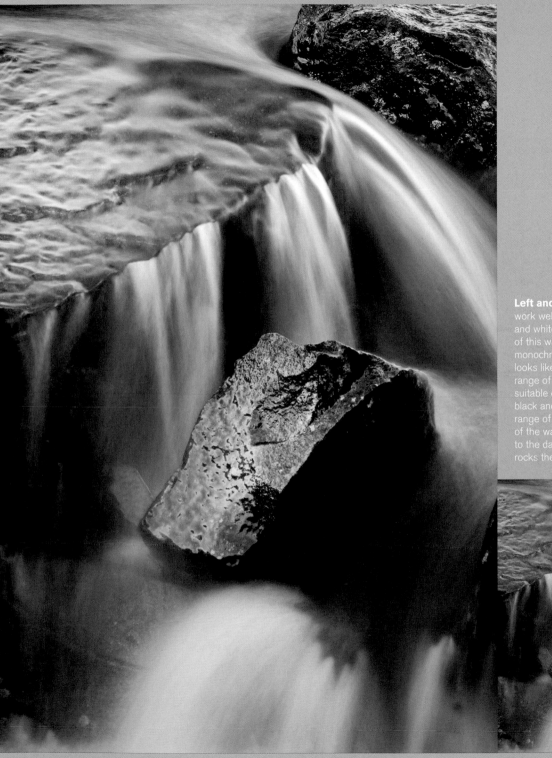

Left and below: Some subjects work well in both color and black and white. The inset color image of this waterfall scene is relatively monochromatic (in fact it almost looks like a sepia due to the limited range of colors). What made it a suitable candidate for conversion to black and white was the interesting range of tones, from the bright tones of the water cascading over the rock to the darker shadow areas of the rocks themselves.

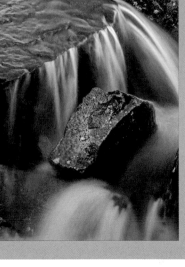

ANALYSIS

After you've finished converting your six images (or shooting, if you've produced them in-camera), print them out, along with the color original, so that they're all the same size. Write the conversion method on the back of each black and white print. Place the black and white prints side by side in the order that you converted or shot the images. If you don't have a printer, view them consecutively one after the other on your computer's monitor.

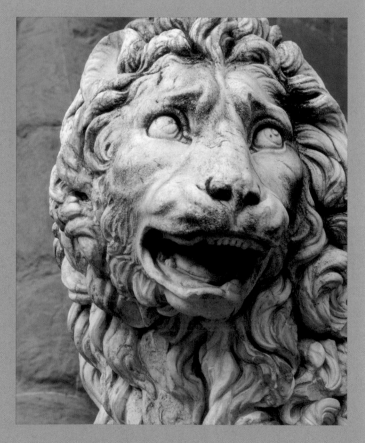

Above: Subjects that are naturally monochromatic, such as this statue, may benefit from contrast adjustments in postproduction more than the use of color filtration.

1 Look at each individual black and white image critically and assess whether the tonal range of that image successfully suggests that you shot objects that were different colors. Once you've looked at each image in turn, rearrange them in order of preference. Think carefully about why you prefer one image over another. This could be in terms of visual appeal or impact. Make notes about which filter produced the most pleasing image. Once you begin to understand how filters affect black and white images, it's possible to anticipate their effect and plan your images using this knowledge.

2 Next, look at the color original. Compare it to your favorite black and white image. Assess them together as to which is the more effective. Not every color image will work in black and white, and learning to recognize what does and does not work is all part of the learning process.

3 To continue the project, consider shooting subjects that are more subdued in color. Convert the resulting images emulating the various colored filters and assess how much difference the filters make.

Above and left: This is the sort of shot that doesn't work in black and white. The main colors in the original—red and yellow—are highly saturated and relatively close together on a standard color wheel. This makes them harder to separate tonally when converting to black and white. The black and white image I managed to create isn't satisfying, despite spending some time working on it.

REFINE YOUR TECHNIQUE

A well executed photographic image deserves to be seen. Once upon a time, photographs would be stuck into an album and then brought out for viewing once or twice a year. Sharing a photo can be a nerve-wracking experience, particularly today as potentially the whole world can see it.

- Today, of course, we have the Internet and photo-sharing websites such as Flickr, and sharing photos on the web can be very beneficial. People, on the whole, will be friendly and if criticism is given it's generally positive. A lot can be learnt from others, especially if you invite comments and comment fairly on the work of others.

- Another way to show your photography off is to have it printed, framed, and displayed in your home or—more daringly—in an exhibition. The size that an image should be printed depends largely on your finances and the image itself. Some images work on a small scale, others really need to be printed large (though obviously this will require greater financial outlay, particularly if you frame the print too). A good source of advice is your local framer. Take samples of your work for reference. Framers are experienced at judging what's right for a picture in terms of size and framing materials.

- Typically, an image should be shrunk so that it's suitable for display on a website—800 to 1000 pixels for the longest edge is a reasonable starting point. Adding a subtle but visible watermark will add some protection against online theft and reuse of your image. If the image uses an Adobe RGB color space, you'll need to convert it to sRGB. When printing, the size of the print will determine whether you need to shrink or even increase the resolution of the image. Once you've adjusted the size, you'll need to sharpen the image for printing. Generally, you need to sharpen more for a smaller print than for a larger one.

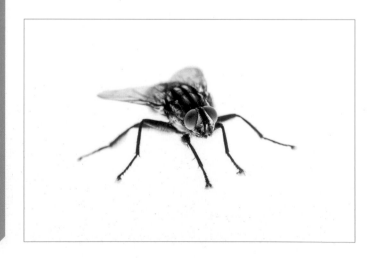

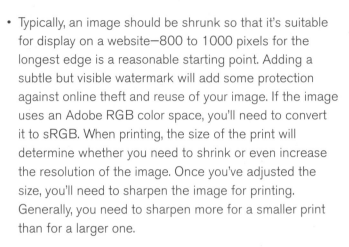

Left: When an image is printed, no ink is applied to the paper where the image is pure white (with an RGB value of 255, 255, 255). Areas that are off-white will receive a very fine amount of ink so that the paper is ever so slightly darkened. To save ink, ensure that your whites are truly white. The background to this image has been deliberately exposed and processed so that it comes out as pure white.

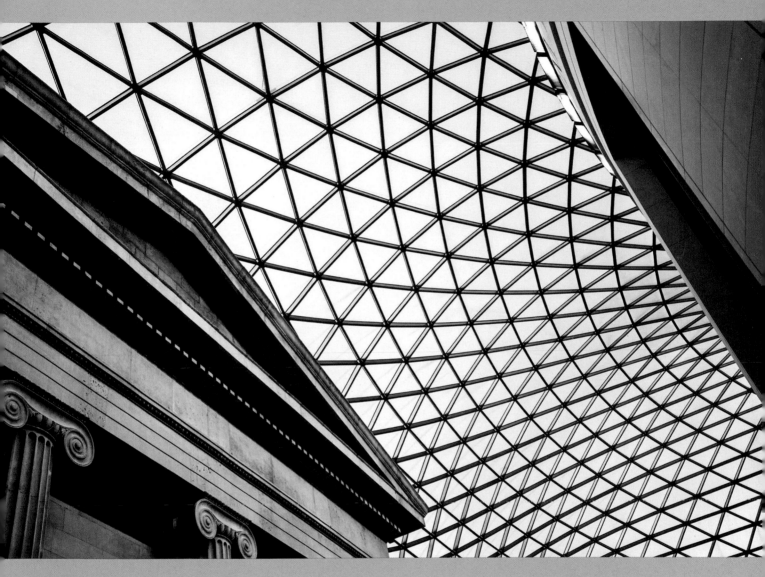

Above: When putting together a collection of images for an exhibition, it's a good idea to have a coherent theme. Part Four of this book covers a range of possible themes that you can try.

SIMPLE SPECIAL EFFECTS

An image file written to your camera's memory card is just the starting point in the creation of the final black and white photo. Effects can be applied to your images to emulate the look and feel of a print made in the analog darkroom.

REALITY VERSUS ART?

Photography is as subject to the whims of fashion as other aspects of human society. During the 19th and early 20th centuries, the dominant photographic fashion was "Pictorialism". Pictorialist photographers weren't interested in documenting reality—they wanted photography to be seen as high art and thought that photographs should be expressive and aesthetically pleasing. Techniques such as soft focus and tinting were used to transform "reality" into an image that was a highly personal statement by the photographer.

Like all fashions, Pictorialism gradually fell out of favor. By the mid-20th century, another photographic trend ruled: "Modernism". Modernist photographers rejected the artifice of Pictorialism and strived to record the world in a crisp, unsentimental, almost austere way. However, thanks to digital photography—and the ease with which postproduction software allows the manipulation of images—it could be argued that Pictorialism has returned. Apps such as Hipstamatic are popular because they heavily alter photos in a way that would make the hair of a Modernist photographer curl in shock.

Pictorialism and Modernism are at two extremes of an aesthetic spectrum. Neither is right and neither is wrong. This Lesson and the next explore some of the ways in which your inner Pictorialist can create an image at the postproduction stage. If you feel you're more of an austere Modernist, skip these Lessons and head straight for the Lesson on documentary photography (see page 118). However, Pictorialism can be fun and is not something you should dismiss lightly.

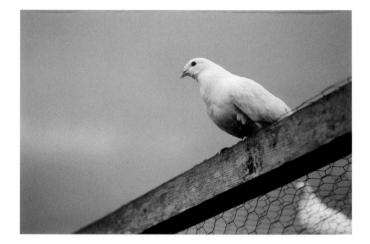

Right and above: A digital file is, if not an entirely blank canvas, merely a starting point. This shot was cropped to improve the composition, toned using a Sepia tint, and then a pale, sharp vignette was added. Compare and contrast to the original above.

GRAIN

Black and white negative film is composed of a strip or sheet of plastic film coated with an emulsion of light-sensitive, silver halide crystals. When light strikes the silver halide crystals, they darken to form a negative image.

The areas of the emulsion that aren't struck by light—the shadows—don't darken, which is why a negative image is formed. The size of the silver halide crystals determines how sensitive to light a particular black and white type film is—the larger the crystals, the more sensitive the film is, and so less light is needed to form an image. If that sounds familiar, that's because it's exactly the same as increasing the ISO level on your digital camera, with noise being analogous to grain.

Film grain has a very organic, random appearance. This has a pleasing character that suits fine-art imagery. For this reason, even though digital noise is often suppressed, the addition of "grain" to a digital image is a valid postproduction technique.

The key to adding grain is to pick your image carefully. Grain reduces the sharpness of an image, hiding fine detail. The addition of grain therefore doesn't suit images that rely on pin-sharp detail for their impact. Portrait images often benefit from grain (which hides lines and wrinkles), as do moodily lit and relatively simple landscape and architectural subjects.

TIP

In Adobe Lightroom, the Grain panel has three sliders. Amount sets the visibility of grain in the image—the higher the value, the more visible grain becomes. Size adjusts the physical size of the grain "particles". Roughness sets the visual character of the grain—a low value creates more regular, sharper grain, and a high value creates less regular, softer grain.

Above: The smaller an image is reproduced—either onscreen or as a print—the larger the grain will need to be in order to be noticeable.

SOFT FOCUS

A soft-focus effect is generally used when shooting portraits. As with grain, soft focus hides—or at least reduces—the appearance of unwanted details such as wrinkles or spots. It's an effect you either like or don't.

Soft focus does add an air of romanticism to a photograph, but it could also be argued that it's manipulative and slightly saccharine. You certainly wouldn't use a soft-focus effect when shooting documentary images. You often see soft focus being used in old black and white movies, although typically more during close-ups of the female lead rather than the male.

A soft-focus effect can be achieved in-camera through the use of a soft-focus (or diffusion) filter. For a more "do-it-yourself" approach you could also try using pantyhose stretched across the front of the lens, too. Another cheap and cheerful way to create a soft-focus effect is to smear a very thin layer of vaseline across the front of an old UV filter fitted to your camera lens (don't smear vaseline directly onto the lens). This method has the drawback that it's messy and the effects are unpredictable. One big disadvantage of creating a soft-focus effect in-camera is that you can't undo the effect later. Adding soft focus in postproduction, although perhaps less fun, gives you more control over the level of soft focus applied.

TIP

In Adobe Lightroom, the Clarity slider is the closest the program comes to a soft-focus tool. A negative Clarity value decreases mid-tone contrast, making the image look softer. However, it's less effective if your image is high- or low-key, as highlights and shadows aren't affected.

NOTES

- Soft focus doesn't mean out of focus. However, you can create a soft-focus effect when taking a long exposure by slowly—and carefully—defocusing your camera during the exposure.

- A really cheap way of adding a soft-focus effect is to breathe on the front of your lens. You'll need to be quick in taking the photograph afterwards, however.

Left: Soft focus works well when shooting delicate subjects such as flowers, particularly when combined with a high-key exposure.

VIGNETTING

Lenses don't always spread light evenly across a digital sensor. The brightest area is in the center of the image, and the image is darker towards the edges. This is most noticeable when using large maximum-aperture prime lenses at their maximum aperture.

As the aperture is made smaller, the darkening around the edge of the image is reduced. By the mid-range of apertures the darkening is often either negligible or non-existent. The darkening around the edge of an image is called "vignetting" (sometimes also referred to as "light fall-off"). Problems with lenses, such as vignetting, can be quantified and corrected either during shooting or in postproduction by the use of the correct lens profile.

However, vignetting isn't necessarily a bad thing. We tend to look at the brightest areas of an image first. If your subject is at the center of the image, vignetting can help to guide the eye towards your subject.

Adding vignetting deliberately in postproduction will also help to "age" a photograph, giving it an antique feel. Reverse vignetting—when the edges of an image are lightened—can also be effective. It's a technique that's most closely associated with romantic subjects, such as portraits of brides at weddings (normal vignetting can create a gloomy atmosphere, which may not be the effect you want for a wedding photograph).

Above: Reverse vignetting works well when your subject is already set against a light background.

TIP

You can correct for lens vignetting using the Lens Corrections panel in the Develop module. However, to add vignetting it's better to use Post-Crop Vignetting on the Effects panel. If you subsequently crop an image in Lightroom, any vignetting you've applied will be altered to suit the new shape.

NOTE

Accessories such as filter holders and lens hoods can also cause vignetting. This is known as "mechanical vignetting".

COLOR

Shooting in black and white was your only option at the dawn of photography. This didn't mean people accepted the situation. By the mid-19th-century photographers used media such as oil paints, watercolors, and pastels to add a splash of color to their work.

The key characteristic of a hand-colored photo is the subtlety and delicacy of the color. The color that's applied has to be translucent so that the photo beneath can still be seen. A similar effect can be achieved by desaturating a color image to the point where it's almost, but not quite, a black and white image (so that the colors in the image have a pastel-like quality).

A currently fashionable technique is to convert an image to black and white, leaving one area of the photo—typically your subject—in color. This works well if your subject is a primary or secondary color.

To achieve the effect, it's better to arrange your composition so that your subject is the only element in the shot that's the desired color. This will make it easier to isolate that color from all the others in the image during postproduction.

TIP

Start with your image in color—don't convert it to black and white. Go to the HSL / Color / B&W panel in the Develop module and select HSL and then Saturation. Move all the saturation sliders to their minimum values, with the exception of the slider that's closest in color to your subject. For added impact, increase the saturation of the slider that's closest in color to your subject.

Left: Bold, bright colors such as red or yellow work well using this technique—they're more eye-catching than blues or greens.

INFRARED

Visible light is just one small slice of the electromagnetic spectrum. Although we can't see infrared (IR) light, it can also be used to make images. This can be done by using a filter attached to a camera's lens that blocks visible light and allows IR light through.

A more permanent solution is to use a camera with its sensor modified by a specialist, so that the sensor is sensitive to, and can make images with, infrared light. It's not something you'd necessarily want to do with your main camera, but it's an interesting option if you've an old and otherwise unused camera body.

Sunlight is naturally rich in IR. This makes landscapes a popular subject for IR photography. Green foliage reflects IR light exceptionally well. When converted to black and white, foliage shot using IR light turns pale, almost snowy-white. Blue sky, on the other hand, tends to veer towards black. Summer, particularly at midday when light from the sun is strong, is the best time to be out shooting IR images. Winter and overcast days tend to prove less successful.

TIP

Emulating the IR look is relatively easy in postproduction. The key—during the black and white conversion process—is to adjust the greens and yellows so that they're very pale, or almost white. Blues should be darkened considerably. IR photos often appear slightly grainy and hazy, too. To mimic these effects, apply grain as previously described in this Lesson and set the Clarity slider to a negative value. Lightroom has a built-in IR preset that produces these effects automatically.

Above: When adjusting the yellow and green sliders to lighten foliage, avoid clipping the tones. Adjust the sliders so that the resulting tones are almost, but not quite, white. Blue sky should be almost, but not quite, black.

SPECIAL EFFECTS

Aim: Shoot a series of five images, of different types, and apply five different special effects to them.

Learning objective: To learn how to apply special effects to images in postproduction editing, and to see which special effect works well with which type of image.

Equipment checklist:
• Camera and lens
• Postproduction software
• Filters (optional)

Brief: Shoot five color photographs, trying to make them all different by shooting a range of subjects—such as a landscape, then a portrait, and so on. If you get stuck for ideas of what to shoot, go to Part Four of this book, where you'll find descriptions of different types of subject.

Once you've shot your five images, import them into your postproduction software of choice. Convert them to black and white and then select an effect described in this Lesson. Apply the effect to the image you think will work best with that effect. Select another effect and another image. Repeat until you've applied an effect to each of your five images.

One of the exciting and challenging aspects of black and white photography is that the image you shoot is just a starting point. The image can be converted using different filters to adjust the tonal range as described in the previous Lesson. Or you can be more imaginative and interpret your image in a more artistic way as described in this Lesson.

Above: Don't be afraid to start again if you think the chosen effect isn't suitable for the image.

TIPS

• If you shoot Raw, you'll be able to alter your images as often as you like and still be able to revert to the original shooting settings. If you've shot JPEG, you don't have this safety net. To ensure that you don't overwrite your original file, make multiple duplicates and copy them into a folder dedicated to this project. Only work on the duplicates and not your original images.

• It's easier to assess whether an effect has worked by leaving a short span of time between the creation of the effect and reviewing it.

Right: This image of a stained brass door handle has been selectively desaturated. Only the red and orange areas of the image retain color—and even they have been subtly reduced in intensity.

ANALYSIS

After you've finished working on your five images, print them out so that they're all the same size, and then view them side by side. Alternatively, if you don't have a printer, view them consecutively, one after the other, on your computer's monitor.

Above: I used a dark vignette on this shot to emphasize the brightly lit leaf at the center of the image. Remember that effects should serve the picture, not the other way around.

1 Look at each image critically, and assess whether the effect you've chosen is appropriate for that image. Think carefully about whether the effect enhances the image or detracts from it. An effect should be sympathetic to the subject and not smother it or divert attention from it. One error that's often made is applying an effect too heavily, or, more rarely, not heavily enough so that the effect looks half-hearted. Consider carefully whether this has happened and what you would do differently next time.

2 Once you've looked carefully at each image, consider starting the project again. Apply a different effect to each image and compare it to the images you created the first time. Having gained experience at applying effects, you may find your choice of effect easier on the second attempt.

3 Consider shooting new images with the aim of applying a particular effect from this Lesson. Producing a final, finished image will be more satisfying when it has been planned from start to finish. Once you feel confident about the effects you can achieve, try to pre-visualize a shot, predicting how it will look once you've applied the desired effects.

Left and below: Ultimately, there's no right or wrong way to process a black and white image. The final image should be your personal interpretation and nobody else's. Don't feel constrained—experiment and have fun. Shoot Raw and you can rework an image over and over again, trying different effects. Here are two versions of one image. The version below is a straightforward, Modernist conversion from color to black and white. The main image is a Pictorialist interpretation. Which do you prefer?

REFINE YOUR TECHNIQUE

Creativity requires experimentation. Don't be afraid to try different effects before you feel satisfied with the result. If an effect doesn't work, it's not a problem.

- If you're shooting Raw, you can unpick an effect and start again. Experimentation can lead to the discovery of new techniques. Sometimes, "mistakes" can be useful too if they point the way to a different method of processing an image.

- If you use Lightroom, you can create virtual copies of your images. Doing this allows you to create multiple interpretations of an image that can be compared to

see which works best. The virtual copies you make are all independent of each other, and don't affect the settings for your original Raw file. And, being virtual copies, they don't physically exist anywhere other than in Lightroom's database. This means that they use virtually no hard drive space.

Below: A black and white image is one step on from reality compared to a color photo. Add effects and the less literal an image becomes. The use of grain and high contrast has helped to disguise the fact that this wildcat is actually a display in a museum. Instead, it looks more like an action reportage shot.

Left: There's no reason not to mix and match effects. This image has had both grain and vignetting applied. However, it's important to apply effects that are sympathetic to an image. In this instance, the vignetting in particular added to the slightly sinister look of the shot.

BEING MORE CREATIVE

One of the joys of black and white photography is that shooting an image is just the start of the creative process. Before digital took over, photographers would take their black and white negative film into a darkroom. It was there that the fun really began.

FILM AND PAPER

The conventional photographic paper used in a darkroom is made by coating a base with an emulsion of light-sensitive silver salts. To make a print, light is projected and focused onto the paper through the negative using a device known as an enlarger. However, just projecting the negative onto photographic paper doesn't produce a visible image; it only produces what's known as a latent image. To reveal the latent image, the paper then has to be immersed in a bath of chemicals known as developer.

Once the image has formed satisfactorily, the development process is stopped by then immersing the print in another bath of chemicals known as the stop. To prevent the image fading, the print is immersed in a third bath of chemicals, known as fixer, before finally being washed in clean water to remove any chemical residue.

An alternative darkroom process is a technique that changes the visual character of a print. This is usually achieved by using non-standard chemicals or, in the case of solarization, exposing the print to light during the development process.

This sort of manipulation isn't available when shooting digitally. Any alteration in the visual character of an image comes through altering sliders or curves. Alternative processes are therefore simulated rather than emulated when using digital images. This Lesson is a short guide to some of the more common alternative processes and how to achieve a similar look in postproduction.

Left: Cameras often have effects modes that are fun to use. However, you typically can't mix and match different effects in the same image. This image was blurred and subtly split-toned using Adobe Lightroom.

Right: The techniques shown in this Lesson rely heavily on postproduction. Solarization can only be achieved after shooting. Some cameras do allow you to shoot toned images, although the range of tones is often limited to one or two (of which sepia is invariably one of the choices).

TONING

The term "black and white photography" implies that all of your images should be a neutral gray. However, this doesn't need to be the case at all. The technique of toning adds an element of color across the whole of a black and white image.

In a darkroom, photographic prints can be toned in one or more chemical baths to achieve a particular effect. The most familiar example of a toning technique is sepia—originally a warm, brown pigment derived from cuttlefish ink. This was such a common technique in the 19th century, that sepia toning is now associated with dusty old photos from a bygone age.

The sepia toning in a photographic print is created not by using ink, but by converting the silver in the print to a sulphide compound. This has the useful benefit of making the print less prone to fading and so longer lasting.

Less commonly known are the toning techniques such as gold toning, which slightly counter-intuitively adds a subtle blue tint to a print, and platinum toning, which has a wide range of color-toning effects depending on the strength of the chemical bath used.

Adding an overall tint to a digital image won't have any effect on how long it lasts, but it's fun to do, and can add visual interest to a black and white photograph. The key with toning is to choose a color that's sympathetic to your subject. Blue is associated with cold temperatures and negative emotions such as sadness or aloofness. More positively, blue is also calming and tranquil. Warmer colors, such as sepia, are seen more positively. However, using sepia can add an unintended patina of age, particularly if there are no modern visual cues in the image.

Left: A sepia tint makes an image appear antique, particularly if the subject seems timeless. To make an image look "older" still, lighten it slightly and reduce the contrast—this simulates fading.

Left and below left: Some subjects suit a narrower range of color tints than others. For instance, warmer tones are more effective for pictures of food (left) than cooler tones—we have an in-built aversion to blue food. Other images are more forgiving—the image below works with both a warm and cool overall tint.

TIP

Lightroom comes equipped with several Presets for various toning options such as Sepia and Selenium (to add a cool-tone to an image). Once an image has been converted to Black & White you can also create your own toning effects using the Split Toning panel. The Hue sliders change the color of the tone, and the Saturation slider controls the vividness of that color—you can also click on the box above the sliders to select the desired color from a panel of colors. Use reasonably similar values for the Highlights and Shadows sliders.

SPLIT TONING

Toning an image involves applying one overall color tint. Split toning refines this by toning the highlights a different color to the shadows. In the darkroom, this is achieved by the use of two chemical baths that affect the highlights and shadows at different speeds. Creating a successful split-toned darkroom print isn't straightforward and requires accurate timing. Because of this it's difficult to create a series of split-toned prints that are identical.

Fortunately, digital split toning is far easier and repeatable. There are no rules as to the colors you can use to tone the highlights and the shadows. As with most aspects of black and white photography, personal taste and what suits your subject are your best guides. However, a good starting point is to tone the highlights a warmer color than the shadows—in real life, shadows tend to have a bluish cast as they're lit by ambient light from the sky above. A subtle combination of yellow and blue or green often works well.

TIP

As with Toning, Lightroom comes equipped with several split-tone Presets. Once an image has been converted to Black & White, you can also create your own split-toning effects using the Split Toning panel (see page 103). The major difference between normal toning and split toning is that the Hue sliders should be set to two different colors deliberately. Use the Balance slider to adjust the color bias between the Highlights and the Shadows. Moved to the right, the color tint of the image will be biased more to the Hue value selected for the Highlights; moved to the left the color tint will be biased more to the Shadows Hue value; set Balance to 0 if you don't want any bias—the colors for both Highlights and Shadows will then have equal weight.

Right: For this image, I decided to use a subtle yellow tone for the highlights as this was close to the original brass color of the battered blowlamp in the foreground.

SOLARIZATION

When a photographic print has been solarized, either the shadows or the highlights (but not both) have been inverted tonally.

Solarization was discovered accidentally in the 19th century. The term solarization comes from the fact that extremely overexposed highlights—such as the sun—would turn white in a negative image rather than the expected black—so that the highlights would be black when a positive print was made. For a long time, solarization was largely a curiosity rather than a technique that was exploited on purpose. The Surrealist photographers Man Ray and Lee Miller began to exploit the effect artistically in the 1930s.

Digital sensors don't work on the same principles as film (or photographic prints) so solarization is impossible to replicate in-camera; it can only be achieved in postproduction as an effect. Solarization is most effective when applied to images with well-defined areas of deep shadow or bright highlights.

Above: Virtually any subject can be used to create a solarized image—it's the lighting that's important. Images that are flat and low in contrast don't work well.

TIP

To create a solarized image in Lightroom you need to use the Tone Curve. Click on the Point Curve button to start editing the tone curve manually. Add a control point approximately halfway along the tone curve. To invert the shadow tones (making them white) pull the control point down to the bottom of the Tone Curve box. Pull the shadow control point at the bottom left of the Tone Curve box straight up to the top left corner. To invert the highlights (making them black) pull the center control point you added to the top of the Tone Curve box. Then, pull the highlight control point at the top right of the Tone Curve box straight down to the bottom right corner. In both instances the tone curve should look like a bell curve.

CYANOTYPES

Cyanotype prints are distinctive because of their subtle cyan-blue and white tones. This effect is achieved by using a solution that consists of an iron salt, such as ferric ammonium citrate, and a second chemical, usually potassium ferricyanide. When exposed to ultraviolet (UV) light these two chemicals produce "Prussian Blue", the pigment that gives a cyanotype print its color.

When the process was first developed, the sun was the only available UV light source. Modern practitioners of the process generally use more powerful, artificial UV lights, similar to those used for home tanning, which greatly reduces exposure times.

Cyanotypes often have a handmade appearance as the solution can be brushed onto any absorbent surface. Watercolor paper is a popular medium, as is cotton and canvas. For greatest verisimilitude, it's therefore worth using similar media when printing your digital cyanotypes. Cyanotypes tend to have a matte surface because of the nature of the media used—gloss printing paper wouldn't be as "realistic". The intensity of the blue in a cyanotype print is controlled by the length of time the print is exposed to UV light—the longer the exposure, the deeper and darker the blue. This variability means there's plenty of scope for personal taste to guide you in preparing your digital prints.

Above: The cyanotype process suits simple subjects—such as this dew-covered cobweb—better than more complex or fussy subjects.

TIP

Lightroom comes equipped with a Cyanotype Preset. However, the result is arguably too pale. The Preset mainly adds a blue tint to a black and white image using the Split Toning panel to achieve the effect. To adjust to suit, change the Hue and Saturation sliders for both the Highlights and the Shadows (Hue and Saturation values of 199 and 12, and 238 and 86 for the Highlights and the Shadows, respectively, are a good starting point).

Left: This image was given the cyanotype look in Lightroom using the method described above. Vignetting and grain were also added to roughen and degrade the image further.

PHOTOGRAMS

A photogram is created in the darkroom by laying out generally flat and simple objects on a sheet of photographic paper. When light is shone down on the paper, the areas covered by the objects are left unexposed. When the paper is developed, the result is a negative shadow, with the exposed areas of the paper turning black and the unexposed areas left white.

Photograms have a very graphic quality as a result of their extreme contrast. Creating a digital photogram is slightly tricky. There are several methods to experiment with. If your subjects are light, stick them to a window and shoot them using a camera, so that there's nothing behind your subject except sky (preferably a bland, overcast sky). Set the exposure for the highlights but focus on your subject—you may need to use positive exposure compensation as exposure is often biased to the focus point. Import the resulting photograph into your image-editing software. Increase the contrast until your subject is a silhouette and

then invert the tonal range (so that black becomes white and white becomes black).

If you've a light box you can achieve a similar effect to shooting through a window. This method is better suited to heavier objects—and has the benefit that you can shoot at any time of day.

TIP

To invert the tonal range of an image in Lightroom, you need to use the Tone Curve. Click on the Point Curve button to start editing the tone curve manually. Drag the highlight control point at the top right of the tone curve down to the bottom right. Then, drag the shadow control point at the bottom left of the tone curve up to the top left.

Left: The most effective subjects for photograms are simple objects with a strong outline. If you use two or more objects, don't overlap them as this will confuse the composition.

Right: Subjects that have a sharp outline tend to work best when converting an image to a photogram. Subjects with soft, fuzzy edges don't suit the high-contrast approach of the technique.

SPLIT TONING

Aim: Shoot five different images, convert them to black and white, and then apply split tones to the shadows and highlights of each one.

Learning objective: To learn how to use split toning effectively and appropriately to your images.

Equipment checklist:
• Camera and lens
• Postproduction software

Brief: Shoot five images of different subjects, such as an exterior image, portrait, and so on. Expose the images so that there's a good tonal range from black through to white. Once you've shot the images, import them into your postproduction software. Convert the images to black and white and export them into a folder created for this project using unique file names.

Next, work your way through each of the images and apply a warm yellow tint to the highlights and a cool blue tint to the shadows of each image. Export the images to the folder, using different file names to the black and white images you created previously. Adjust the tinting of the

highlights and shadows of the images, this time using your own judgement for each image. Think about the effect the colors will have on the perception of each image. Apply colors that you think are sympathetic and will enhance an image rather than detract from it. Export these images to your project, again using unique file names.

Above: Strongly saturated colors that clash generally don't work well, other than to give an image a surreal, other-worldly quality.

TIPS

• You can shoot black and white in-camera but for best results shoot in Raw and convert the resulting color files to black and white.

• Color can be used to convey emotion and temperature.

• The more saturated the colors you use, the more garish the resulting photo will look. Adjust the color so that they're subtle but not too subtle.

Right: Colors that are close together on a standard color wheel, such as yellow-green and green-blue used here, are effective when used together.

ANALYSIS

Once you have saved the files, either print them off or view them on your computer screen.

1 Compare each standard black and white image to the two split-toned versions you created. Assess whether the split toning you applied enhanced the image or if the original black and white version is more effective. If the latter, note why you think this should be. Common reasons for this are that the two colors are not harmonizing (creating a discordant clash), or that the colors are too garish.

2 Compare the two split-toned versions of each image. Warm yellow highlights and cool blue shadows are a common way to split tone an image, but it's not the only answer. Which version of the split-toned image do you prefer? Note what you think makes one more effective than the other. Think in terms of how sympathetic to your subject the colors are.

3 To continue the project, consider shooting images solely with the intention of split-toning them in postproduction. Think carefully about how you would split-tone them, including the colors you'd use and their level of saturation.

Above: Warm shadows and cool highlights are slightly disturbing as they reverse our normal expectations of how highlights and shadows work (even if only subconsciously). However, this can be very effective if you want to create an unsettling effect.

Above: Don't be afraid to mix and match the techniques in this and the previous Lesson. This image was created by split toning, adding grain and a vignette, and then softening the image by using a low Clarity value.

REFINE YOUR TECHNIQUE

This Lesson has only described a few of the very many alternative processes that were—and still are—used to make darkroom prints. Unfortunately, Lightroom and Raw-conversion software in general aren't ideal for the emulation of truly unusual techniques such as Gum Bichromate, which involved physically manipulating a print with brushes during the darkroom development process.

To go further with manipulating your black and white images a graphics software package such as Photoshop is required. However, it's worthwhile investigating other alternative processes. Even if you can't emulate them, they may help you to see your images and the way that you shoot in new ways. It's impossible to have too much knowledge about any aspect of photography.

Ultimately, a photographic image needs to be printed. Prints have a tactile quality that a screen can never match. The most common type of paper used for digital printing is gloss. There's a good reason for this—gloss paper has a strident punch that can enhance most images. However, it's not subtle. Some images are better served by being printed on semi-gloss or even matte paper. These types of paper are particularly suited to techniques such as cyanotypes (which are often created using watercolor paper in the darkroom). Experimenting with paper can be costly, though some manufacturers do sell sample packs. Once you're familiar with the qualities of a particular paper, it is easier to know which images will work when printed on it and which images won't.

Left: One type of effect that Raw-conversion software can't replicate is overlaying one image on top of another. This is more the province of graphics software such as Photoshop. This ragged-edge effect was achieved by scanning a sheet of paper that had been drawn on in thick black pencil. It was then overlaid above a cyanotype image using Photoshop's Layer function.

Above: There's no one right way to achieve black and white image effects, such as solarization pictured here. Ultimately it's your own personal interpretation of the image that's important. Experimentation is the key, something that is especially suited to working with Raw files.

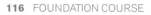

PART FOUR
SUBJECTS

Although you like photography—or you wouldn't be reading this book—you probably have a preference for what you shoot. All photographers bring their personal preferences to bear on the type of photographer they are.

A photographer generally defines themselves by the type of photography that interests them enough to make it their speciality. I think of myself as a landscape photographer because it's the natural world that I find most interesting. Having a photographic speciality that you enjoy is important. There are times when photography can be frustrating (even for experienced photographers), so without a passion for your particular interest it's all too easy to become dispirited and even be tempted to give up.

However, that's not to say that you shouldn't try other types of photography occasionally. Photography is a creative endeavor, and creativity needs to be constantly fed with novelty and new stimuli. Although landscape photography is my "genre", that doesn't mean that it's the only photography that I'm prepared to consider—although after one attempt, I know that wedding photography really isn't for me. Hopefully Part Four will help to inspire you to expand your photographic repertoire.

Above: Even though I default to landscape photography as an interest, I can't help but photograph any subject that I find visually interesting.

Left: There's nothing I like better than standing on a windswept hill, watching the play of light on the landscape, as clouds scud past. The very idea of this may leave you cold, but that's the wonderful thing about photography and photographers—we all have a unique view of the world, which we bring to our photography.

TELLING A STORY

A documentary photographer is a storyteller who uses pictures instead of words to tell the story. What that story should be is entirely up to the photographer.

LEARNING TO EDIT

Writing a short story requires a different level of commitment to writing a novel. The same is true of shooting documentary photographs. Street photography, in which the photographer shoots on a whim without working to produce a coherent set of images, is analogous to the short story, whereas a long-term project, in which the photographer invests time getting to know their subject, is akin to writing a novel.

A story can be told in one defining image (often the case with street photography). However, it's more likely that you'd shoot a series of images over the course of a long-term project. This means that you'll need to edit your shots to produce a strong body of work, just as a novel is edited after the first draft. During the editing stage, you'll need to be ruthless—discard any image that weakens or is irrelevant to the story you're trying to tell. It's better to have a small, but tight, set of images than an extensive, "flabby" set.

Left: A strong set of photographs will be varied: Don't repeat yourself and try to shoot a mix of images: some that set the scene and others that record the quirky, and often overlooked, details of your subject.

Above: Documentary photography can be fuelled by many different emotions. Anger—at injustice, or waste, or any number of different factors—is as good a fuel as any. However, passion or enthusiasm for a topic is just as valid.

PLANNING

When starting to shoot documentary photographs, you should think hard about what interests you. If a long-term project appeals, you'll need to be interested in the subject to see the work through to the end, and even to return periodically to the subject after completion.

Documentary photography is most closely associated with social subjects—telling people's stories. To be successful at a social project you'll need good people skills: there's little point in embarking on such a project if you're tongue-tied when dealing with people.

Committing long-term to a social subject is often necessary to allow your subjects time to get to know you and, more importantly, so they no longer notice you or your camera—it can take days or even weeks before you fade into the background sufficiently. People often act unnaturally before they get used to having a photographer around.

The story you want to tell will need to be discussed with your projects too. If you're clear at the start of a project then there's less risk of people being upset if they don't like what you've done by the project's end.

> **NOTE**
>
> Another aspect of planning a project is knowing how local laws will affect what and where you shoot. Some countries have now banned candid photography of people, for example, whereas elsewhere such photography may not be banned but it may not be tolerated either.

Above: Experience has taught me that busy events make it difficult to get close to the action. Telephoto lenses therefore prove more useful than wide-angle lenses.

EQUIPMENT

You don't need particularly sophisticated camera equipment to be a documentary photographer. Many of the most successful documentary photographers of the 20th century were renowned for using simple cameras with a handful of prime lenses. In fact there is a lot to be said for this approach, not least because it's less intimidating for your potential subjects if you use a small, simple camera.

The favored primes were the 35mm and 50mm (on a full-frame camera or their equivalent on other camera systems). A 35mm lens, with its wider angle of view, allows more room to maneuver than a 50mm lens, so is arguably preferable—you could crop down an image shot with a 35mm lens, whereas a 50mm may be too tight for further cropping. The reason that some street photographers are so successful with their limited lens range is that they are familiar with the angle of view of those lenses. This means that compositions come naturally, often worked out in a split-second as the photographer brings the camera up to their eye. Zoom lenses, though useful, add an extra layer of thought (you may need to turn the zoom ring) that can produce an unwanted delay.

Another useful aspect of using prime lenses is that they typically have large maximum apertures. This is a benefit, as you may have to work in less-than-ideal light but also want to avoid camera shake if possible. Using a moderately high ISO (or even Auto ISO) will also be of benefit.

Above: Image stabilization systems (both in-camera and built into a lens) are ideal when you can take an unhurried approach to your photography. A stabilized lens enabled me to handhold the camera when shooting this picture without using a particularly high ISO. Stabilization systems are less useful when you're shooting quickly and moving from shot to shot—they need a second or so to settle and provide maximum stabilization.

THE DECISIVE MOMENT

When shooting documentary photos, there is often one precise moment when you need to press the camera shutter button in order to make the most satisfying image possible. This is when the various elements of your image are in their optimum position in front of the camera. This optimum position either creates a powerful composition, which wouldn't have been possible at any other moment of time, or most successfully conveys the story you're trying to tell.

The idea of the decisive moment was first put forward by the French photographer, Henri Cartier-Bresson, in his influential book *Images à la Sauvette* (*The Decisive Moment*), first published in 1952.

Watching for the decisive moment takes concentration. You need to be aware of what's happening around you so that you can anticipate events as they unfold. A momentary lapse in concentration and the decisive moment will be lost. Being ready for the decisive moment also requires that you're familiar enough with your camera that you can use it intuitively and without hesitation.

NOTES

- Pre-focusing and using a mid-range aperture such as f/8 will speed up the shooting process, and make it more likely that you'll capture the decisive moment.

- The true practitioner of the decisive moment would only take one or two shots at most. Firing off a rapid sequence of images using continuous shooting is arguably cheating.

Above: This shot was created purely by chance as I passed a soccer field occupied by sheep. Lucky shots such as this can't be anticipated and so require complete familiarity with your camera equipment. You have to point and shoot reflexively, but still create a usable photo.

HUMOR

You don't have to be serious when shooting documentary images. The world—and your images—can be funny too. There's just one problem: what you find amusing may leave another cold. The key is not to worry about this—you won't please everyone with any image you shoot, regardless of the subject. Knowing this makes the reward of amusing someone who is on your wavelength all the sweeter.

There are essentially three types of humorous image. The first (and simplest) is one that's simply a record of something intentionally funny—a photo of a sign deliberately created to amuse, for instance. The second is a record of a funny event, such as a pet showing unexpected behavior—again, the definition of what constitutes a funny event will vary from person to person. The third type is the most subtle of the three: a photo of an incongruous juxtaposition. It's also the hardest to shoot as it requires you to see the humorous connection between two or more otherwise unconnected subjects, and for your juxtaposition to be clear enough that others can see the connection in the final image too. Although that may sound daunting, it is a skill that can be honed with practice, though you do have to have a slightly skewed view of the world in the first place!

Left and above: Two juxtapositions that struck me on two separate days out. The shot (left) in the Ashmolean Museum in Oxford required careful and considered positioning of the camera for the juxtaposition to work effectively. The second shot (above) happened more instinctively as the cloud—seemingly blown away by the PA system—was moving too quickly and the shot would have been lost if I'd hesitated.

TIP

You never know when you'll come across a scene that tickles your funny bone. For this reason it's a good idea to always have a camera with you wherever you go—cellphones and compact cameras are ideal for this purpose.

Left: Documentary photography often involves leaving your comfort zone and meeting the types of people or going to places you wouldn't normally consider. This takes courage and isn't for the faint-hearted. Some documentary subjects have inherent risk. It's up to you to decide whether that risk is worth taking in order to find out something new about the world and, perhaps just as importantly, about yourself.

SHOOT AN EVENT

Aim: To shoot 10 different images of a special event that record key moments, people attending, and activities.

Learning objective: To learn to record special events and people in images, and to create compelling images that tell the story of an event and also capture the characters and feelings of the people on the day.

Equipment checklist:
• Camera
• Zoom lens— preferably wide-angle to short telephoto
• Spare batteries

Brief: Plan a visit to a local organized event (this may be easier in summer). Research what will happen during the event so that you minimize any surprises on the day. On the day of the event, shoot 10 photographs that you feel successfully capture the day. Try to make each photo visually and thematically unique if possible. Shoot not only the event itself but also the setting up of the event and its aftermath, as well as reaction shots of people enjoying the proceedings—or not, as the case may be. Shoot either black and white or in color with the intention of converting to black and white in postproduction.

TIPS

• Arrive at the event before it starts. This will enable you to spend time working out potential locations for shots before the action commences (and will allow you to stake your place before the crowds arrive).

• Try to get a timed schedule of the event. If the event is spread across a wide area, try to get a map so you don't waste time finding your way around.

• Don't be afraid to push yourself politely into the best position for a shot.

• A zoom with a wide focal length range will save you swapping lenses—you could miss a shot otherwise.

• Contact the organizers of the event beforehand to check whether photography is permissible if you're uncertain.

Left: Look for interesting details that help to tell the story of the event. A scoreboard at a sporting event is a literal example of this type of detail.

Right: People engrossed in an activity tend not to notice cameras. You won't be the only photographer snapping away too. This makes for an ideal opportunity to shoot interesting candids.

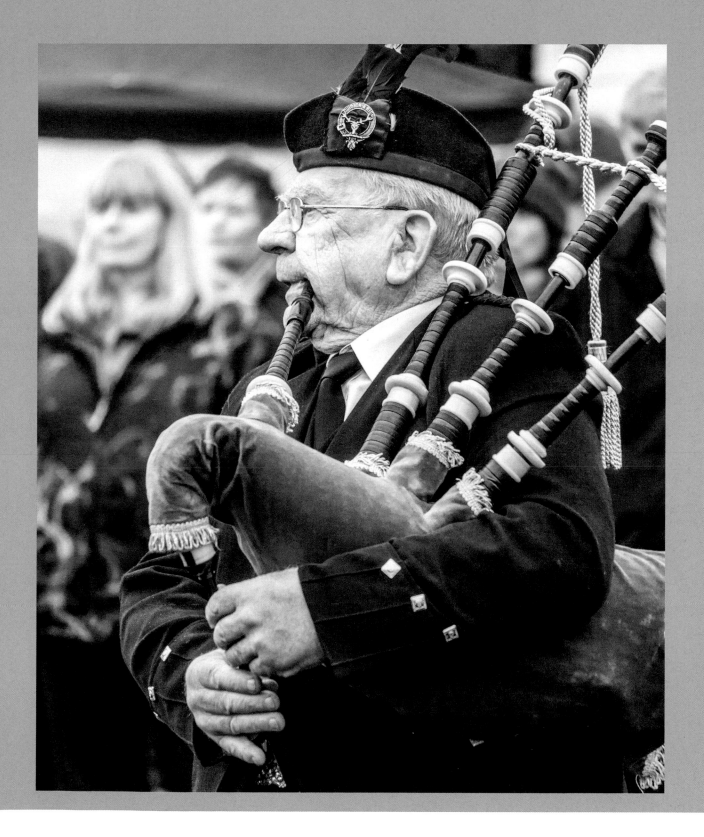

ANALYSIS

Convert your 10 images to black and white. Once you've done this, print them all out at the same size and view them individually in chronological order, or view them on your computer monitor sequentially.

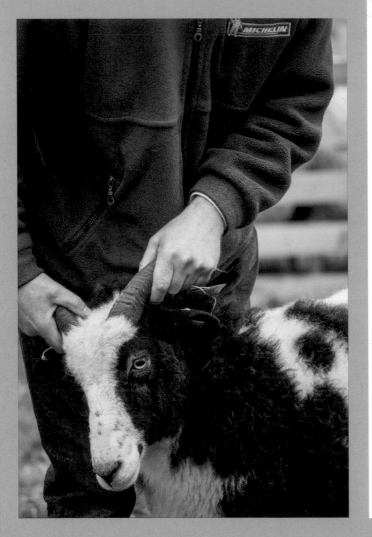

Above: Telephoto lenses allow you crop tightly on your subject and avoid distracting details. I use a telephoto lens a lot to shoot the more quirky side of events. You often can't get close to the action, which rules out the use of a wide-angle lens.

1 Assess each image individually as to whether it successfully captures a particular moment in time at the event. If it doesn't, consider why this should be. This could include aspects such as your viewpoint at the time of shooting (were you too far away or even too close?), or even mistiming the shot so that you missed the peak of the action (or the "decisive moment").

2 Look at the images as a set, again arranging them chronologically. Assess them to see if they work better individually or as a set. It's often the case that images need to be seen in context with others in order to have impact.

3 Arrange the set of images in order of preference. Remove your two least favorite images. Does that improve the strength of the remaining images as a set? Documentary photographers need to be objective about their work and able to edit sets of images down to produce a strong body of work. It can be difficult to be objective—sometimes you may find that an interesting image photographically may not advance the story you want to tell.

4 Once you've assessed the images, make notes about what went right at the event and also, perhaps more importantly, what (if anything) went wrong. Making mistakes is forgiveable, repeating those mistakes less so.

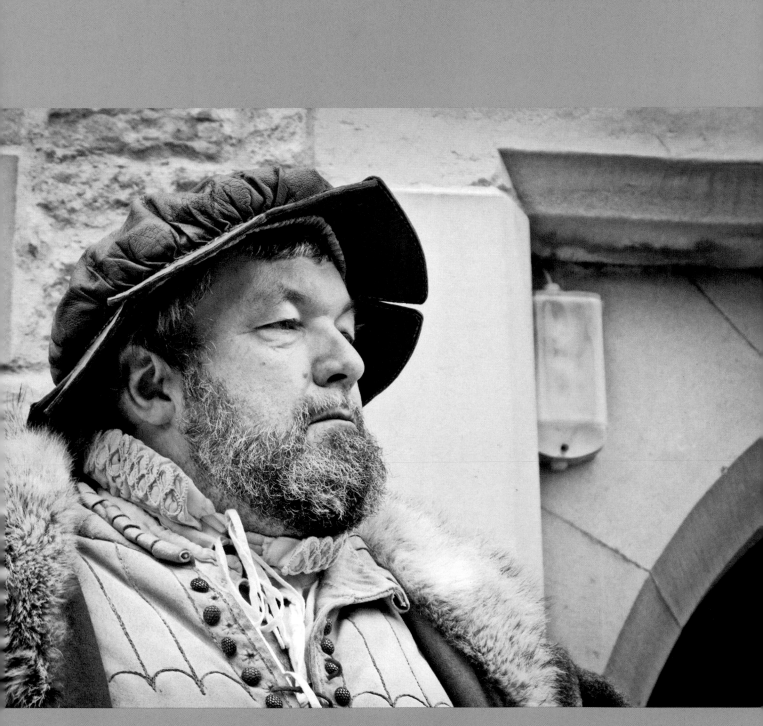

Above: Documentary photography means creating images that may have historical importance in the future. By shooting such photographs, you're creating a record of life as it was lived at the time.

REFINE YOUR TECHNIQUE

Documentary photography is difficult and time-consuming, so be prepared to spend the time researching your subject, as well as getting to know the people and events involved. The more informed you are, the more you can focus on telling the story.

• How you compose your documentary image will determine how much information is conveyed in the image. Wide-angle lenses will help you to create photographs that show context and set the scene for the story you want to tell. Longer focal length lenses will let you create more intimate images that highlight particular details.

• Research before an event or prior to starting a project is vitally important. If your project focuses on a particular event, you'll need to know in advance what is due to happen and when. It's useful if you can visit the venue or location beforehand. This will save time on the day itself, as you'll know your way around, and it will also avoid the embarrassment of getting lost if the venue is particularly complex. In addition, it helps in planning what shots are possible and even what equipment (especially lenses) will be needed to achieve those shots. Public domain resources such as the Internet are invaluable. However, talking to relevant individuals will allow you to get a more personal take on how your project will unfold.

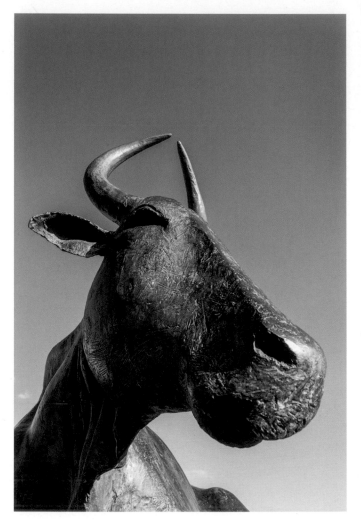

Above: There's arguably more of an ethical dimension when shooting documentary images than other types of imagery. The use of ultra-wide angle lenses will add distortion that's not a true reflection of reality—and so may do a disservice to your subject.

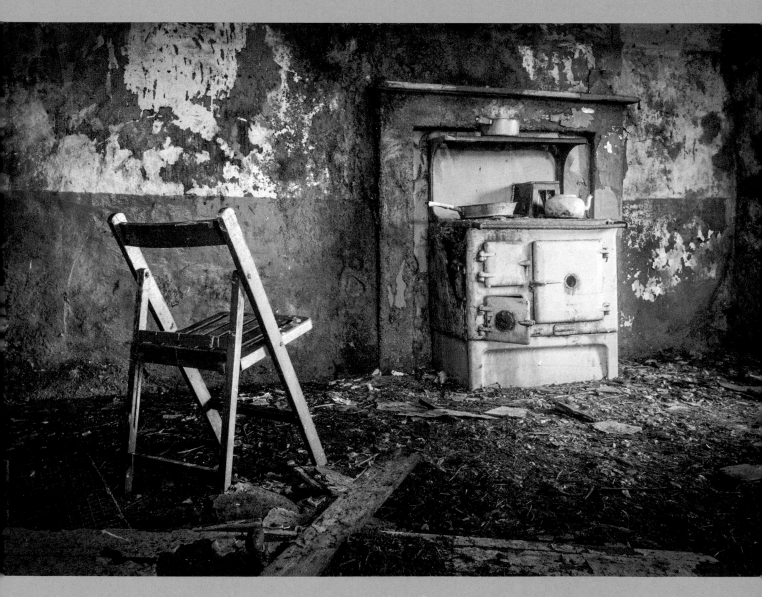

Above: Ethics also come into play when converting documentary images to black and white—you make aesthetic judgements that affect how that image is perceived by others. A documentary image can never be an objective reflection of reality, but you shouldn't allow style to drown out the message you want to convey.

MAKING PORTRAITS

People are social creatures, so it shouldn't be surprising that portraiture is such a popular, perhaps even the most popular, photographic subject.

EMPATHY

Shooting a portrait means striking up a relationship—even if it's fleeting—with your subject. Portrait photographers therefore need good people skills. It's common for people to complain that they "don't like having their picture taken", and it's understandable. Being the subject of a photograph means being the center of attention. If a person isn't feeling their best or doesn't like the way they look, then they won't want a permanent record of that particular moment in their lives. Being able to overcome this resistance requires tact and patience, and also the ability to recognize when to give way gracefully and not press the matter.

Even after being persuaded, your subject may be nervous or shy. This can be overcome by taking your time and talking to the subject as you shoot. Explain what it is you're hoping to achieve and how your subject can help. Show them the results on your camera's screen, or on a tablet computer if you can send images to it wirelessly. As people become used to the camera, their natural reluctance does tend to diminish. Praise your subject as you go along but look for signs that they're flagging, and stop the session if you think they may get fractious.

Above: Gaining the trust of an animal is just as important as gaining the trust of a person. Getting down to the eye level of your subject will make you appear less intimidating.

NOTES

- Children often have less reluctance to pose for a shot than adults. The downsides are that their attention span tends to be shorter and they sometimes play up for the camera. For quieter, more natural photographs, allow time for a child to forget about the camera. Toys and books are a good distraction and may elicit interesting reactions as they play or read.

- Animals are less easy to control than people, although they don't have the same wariness of a camera as people, of course. Patience is once again a virtue. Be prepared to shoot multiple shots until you have the pose or the expression that you're seeking.

Right: Having your subject stare directly at the camera makes a powerful statement—and sometimes an uncomfortable one for the person looking at the final image. A more ambiguous effect is achieved by having your subject deliberately not look at the camera. This leaves the viewer of the image more scope to interpret your subject's feelingss.

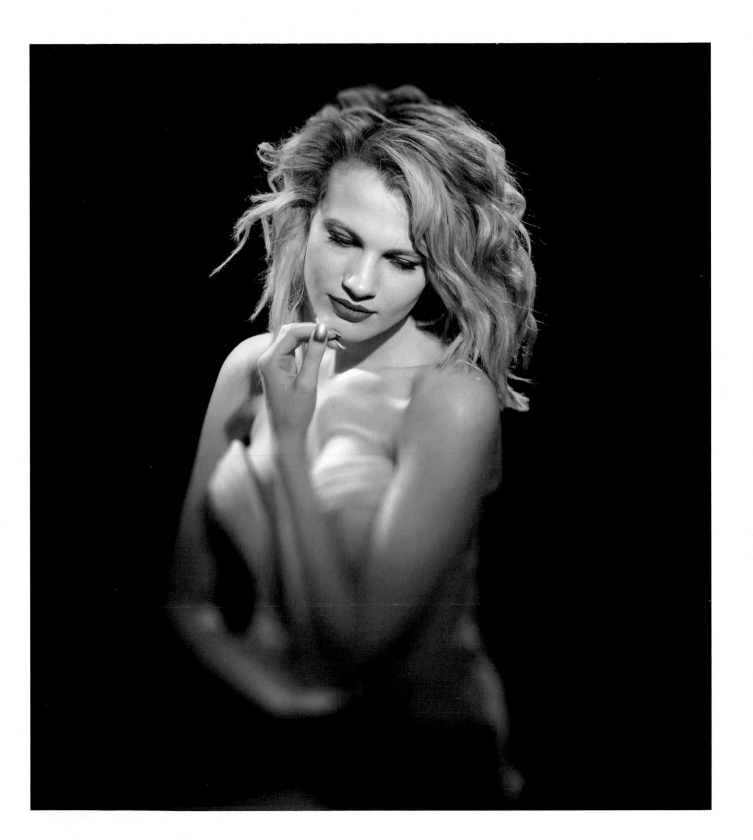

COMPOSITION

The simplest type of portrait is the vertical "head-and-shoulders" shot that, as the name suggests, frames your subject tightly in the image and shows little of the background. However, composing this way doesn't put your subject in context. Shooting horizontally and with a wider-angle lens will allow a looser, more contextual, composition.

Generally, if the person you are photographing is looking directly at the camera, the camera should be at your subject's eye level. Forcing them to look up or down at the camera can result in your subject assuming an awkward posture, which won't be aesthetically pleasing. However, this is one rule that can be broken to good effect, and you can experiment with shooting from an unusual angle if it feels right.

If a person isn't looking directly at the camera, we tend to follow their gaze through the image space. This can be used as a very powerful way of pointing towards another area of interest in a shot—such as an object associated with the subject or a detail in the immediate area.

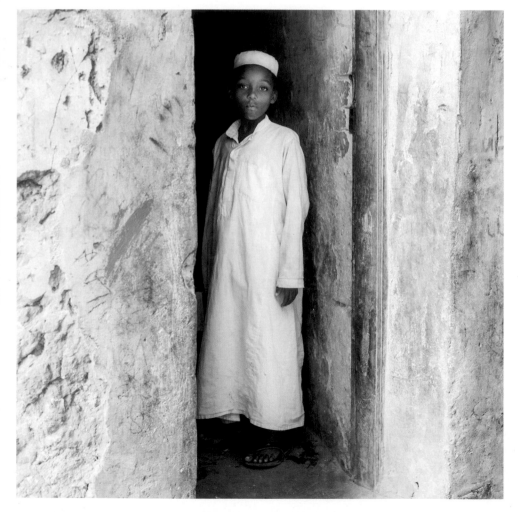

Left: This boy is looking directly at the camera. However, his expression is hard to read, making the image slightly ambiguous. Is he happy, sad, or bored? Ambiguity engages the viewer, encouraging them to project their own feelings onto an image.

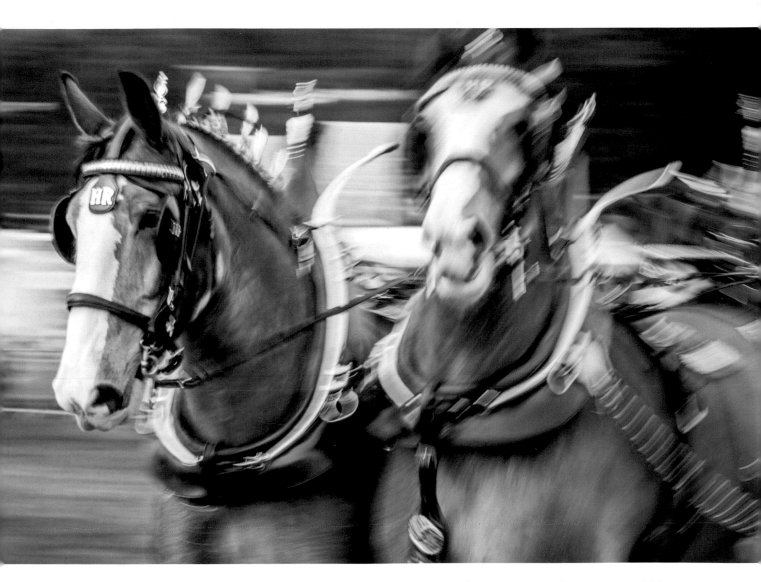

Above: A successful portrait, whether of a person or an animal, captures something of their personality. With this shot of two display horses I used a shutter speed of 1/15 sec. to convey a sense of their speed and power.

LIGHTING

Portraits can be shot outdoors very effectively. However, moving indoors and using artificial light sources will give you more control over the quality of the lighting. There are two types of artificial lighting system to consider: flash and continuous lighting.

FLASH

The most commonly used artificial light source in photography is flash. Most cameras—with the exception of some high-end DSLRs—feature a built-in flash, which is a useful, though limited, tool: a built-in flash is mostly used as a fill-in light to illuminate a backlit subject so that it isn't recorded as a silhouette.

There are two problems with a built-in flash, however: it won't be particularly powerful, which means your subject has to stay close to the camera; and it provides an unflattering, hard frontal light. A better option is a separate flashgun, often referred to as a "speedlite", which fits onto a hotshoe on the top of the camera. Flashguns are generally far more powerful than a built-in flash, and most have the useful feature of a tilting head. This allows the use of bounce flash, where light from the flash is reflected (or bounced) from a neutrally-colored surface, such as a ceiling, down onto the subject. This provides softer, more flattering light than if the flash had been pointed directly at the subject.

An even better solution for modifying light from a flashgun is to take it off the camera altogether. This enables you to position the light very precisely for the required effect. Off-camera flash is achieved in one of two ways. The simplest method uses a connection cord between the camera and the flash—this is cheap and cheerful, although there's always the danger of tripping over the cable and pulling the flash or the camera (or both) onto the floor. Wireless flash uses either an optical, infrared beam or a radio signal to trigger the flash.

Optical systems require a "master" flash that emits an infrared signal to cause a "slave" flash to fire. This means

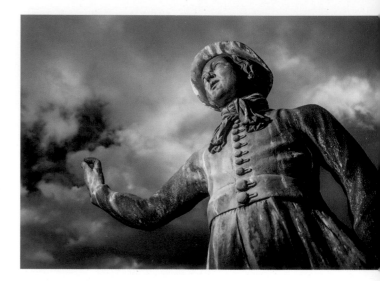

Above: This image was created by positioning a flashgun above the camera and to the left of the statue. Using the flash on-camera wouldn't have produced such pleasing lighting.

you need at least two flashguns, although some built-in flashes can act as a master flash. Another drawback is that the master and slave flashguns need to have line-of-sight of each other, otherwise they won't fire, but the signal can often reflect off walls and ceilings indoors, which is less limiting. Optical systems don't have much range either, and the various flashguns need to be kept relatively close to each other.

This doesn't apply to radio-based systems. These use a radio transmitter fitted to the camera hotshoe that sends a signal to a receiver fitted to the flashgun. Line-of-sight generally isn't necessary and the range is far greater than with an optical system. The drawbacks to the radio-based systems are that they are expensive and flash exposure must be set manually—through-the-lens (TTL) metering is generally not supported.

CONTINUOUS LIGHTING

Another solution is continuous lighting. These systems use incandescent, fluorescent, or LED bulbs. LED lights are particularly power-efficient and don't generate much heat. Heat from a continuous light can be problematic: it can be uncomfortable for your subject to sit under hot lighting units for any length of time. The two big advantages a continuous light has over flash is that setting exposure is simpler, and you can also see immediately how the quality of the light changes as you move it around your subject—you would need to shoot a series of test shots with flash. There are, of course, a few downsides. When shooting portraits, continuous lighting will cause your subject's pupils to contract. Although this may seem minor, larger pupils are generally seen as more aesthetically pleasing, especially when shooting portraits of women and children. Continuous lights can also be far more bulky and, therefore, less portable than flash—this is less of a problem if you have a permanent studio setup.

NOTES

- The power of a flash is determined by its Guide Number. The higher the Guide Number, the more powerful the flash, and the greater its effective range at a given aperture and ISO setting.

- The smaller the aperture, the shorter the effective distance of a flash. This can be offset by the use of a higher ISO. Shutter speed has no effect on flash exposure.

- Flash exposure can be determined automatically if a camera supports TTL metering. Set a flash to manual exposure and you will need to work out for yourself the aperture and ISO required for a correct exposure. There are various apps available for smartphones that take the head-scratching puzzlement out of this process.

Above: The eyes of your subject are visually "heavy". We tend to look at eyes in an image first before casting our gaze around the rest of the face. This is true regardless of whether your subject is human or animal. For this reason, it's important to ensure that your subject's eyes are pin-sharp by focusing on them (either by moving the active AF point over the eyes or by physically moving your camera to focus, locking AF, and then recomposing). Notice how in this image the nose of the goat is unsharp. This is far less noticeable than out-of-focus eyes would have been.

PERSPECTIVE

Aim: To shoot four or more portrait photographs using different focal lengths.

Learning objective: To understand the effects of using different lenses on portrait composition.

Equipment checklist:
• Camera
• Zoom lens that includes a wide-angle setting (24 or 28mm full-frame equivalent) to a short telephoto (70mm full-frame equivalent)

Brief: Shoot four or more head-and-shoulder portraits of a willing subject. Use either a vertical or horizontal format, but keep the orientation consistent once you've made the first image. Shoot using aperture-priority and select a mid-range aperture such as f/8. Use a higher ISO setting if the resulting shutter speed may cause camera shake. Zoom lenses generally show standard focal lengths on the lens barrel (28mm, 35mm, 50mm, and so on). Shoot your first portrait with the zoom set to its widest focal length. Get in close to your subject so that their head almost, but not

quite, fills the frame. Then move the zoom ring to the next marked focal length. Step back until your subject's head is approximately the same size and in the same position within the frame as the first shot and then take another photo. Repeat, moving the zoom ring to each successive marked value until you've reached the longest focal length on the lens.

Typically, you wouldn't use a wide-angle lens for a close-up portrait (you'd need to stand very close to your subject and the resulting perspective wouldn't be flattering). Short telephoto lenses are more often used for close-ups, as these allow you to stand further back from your subject, and this results in a more natural perspective. However, this is a rule that can be broken for effect.

Left: If you have limited space to work in, it may mean you have no choice but to use a wide-angle lens. This was the case with this shot, which is slightly unsatisfying as a result.

TIPS

• You'll need a patient subject for this project, as the setting up may take some time. If you've a Wi-Fi-enabled camera and smartphone app you could potentially create a series of self-portraits, or "selfies".

• Work in an area that allows you to move around freely.

• Try to keep the light consistent. If you work outside, it will be easier to photograph on an overcast day, when there's little light variation during the time you work on the project.

• Focus on your subject's eyes. Use your camera's "face detection" function, if it has one, to make this easier.

• Either shoot in black and white in-camera or convert to black and white in postproduction.

Above: Superficially similar to the portrait opposite, the shot benefits from the use of a lens with a longer focal length and a more natural perspective.

ANALYSIS

Print out the original five color images and then lay them out in order of shooting, or view each image consecutively on your computer screen.

Above: The use of longer focal length lenses to shoot portraits is highly recommended if you don't know your subject—you can can keep your distance and not invade their personal space.

1 Compare the images and note how the perspective changes between each shot—even though your subject's head should be the same size in each image, there should be a noticeable difference visually.

2 Rearrange the images in order of preference. Think about why you prefer your favorite image over your least favorite. This could be because your favorite image shows your subject in a more flattering way, or even because it has greater visual impact. Note the focal lengths used for both shots.

3 There is no right or wrong answer to the lens you use to shoot a head-and-shoulders portrait. Although typically you would use longer focal lengths, wide-angle lenses do produce a unique look. If you have an even wider-angle lens (such as a fisheye) shoot a similar head-and-shoulder shot with this. You'll need to be extremely close to your subject to do that. The results will be unflattering but also striking—you'll need a subject who's not going to take offence.

4 Look at the background behind the head of your subject. Compare how sharp it appears—it should be progressively less sharp the longer the focal length of the lens. However, you may find that it's not entirely out-of-focus in any of the shots. Photographers often shoot portraits so that the background is blurred and so less distracting. Throwing the background completely out-of-focus would require the use of a relatively long focal length lens and a wider aperture than f/8—typically, you'd use the lens's maximum aperture. If you have a telephoto lens, try shooting a similar portrait to the one you took in the project, using the maximum aperture of the lens. As depth of field may be extremely limited, you'll have to focus very precisely on your subject's eyes.

Left: Showing your subject in their surroundings is known as "environment portraiture", and this enables you to reveal a particular aspect of their life, such as where they live or work. This type of portraiture invariably takes more time to set up than a simple head-and-shoulders shot. It's important to engage your subject during the setting up process, and keep them interested in what you're trying to achieve. A bored subject won't be at their best in the final image.

REFINE YOUR TECHNIQUE

Portrait photography is a challenging discipline, requiring you to master many different skills, from lighting and composition, to learning to put people at their ease.

- Portraiture is as amenable to the use of special effects as any other genre of black and white photography. The key—as always—is to apply effects sympathetically. It's a slight cliché but a high-key, soft-focus approach works well with children and female subjects. Low-key, gritty graininess is seen as more appropriate for male subjects. Consider revisiting the portraits you shot for the project and applying different effects to see the difference they can make.

- Hard lighting can be used to emphasize texture—lines, wrinkles, and bumps—in a person's face. Some people may not appreciate this more honest approach to portraiture, however!

- Talk to your subjects beforehand if you're using a lighting setup. Their input can be invaluable when positioning lights. If you produce an image that your subject is unhappy with, they'll be reluctant to pose for you again. However, if your subject is willing, try using unusual lighting setups to see the effect they have on the final images.

Left: Effects such as sepia toning work well with portraits. Avoid the use of cooler colors when tinting, as they can make your subject look sickly. The exception to this is when you want to emphasize or convey a negative emotion, such as depression.

Above: Using a simple background will help to focus attention on your subject. In this instance, the background was complex so, to simplify it, I used the maximum aperture of the lens, restricting depth of field. The downside to this was that I had to ensure that I focused precisely on the subject's eyes. The limited zone of sharpness didn't leave much room for maneuver.

LIGHT

Landscape photography concerns itself with the natural world. Architectural photography involves shooting the built environment. Despite this inherent difference, the two are very similar and there is much overlap in terms of technique and planning.

PLANNING AHEAD

All photographic subjects benefit from being shot in sympathetic light. Landscape and exterior architectural photography both put you at the mercy of the weather, which affects the quality of light from the sun. The hard light of a cloudless sunny day is generally less suitable for landscape subjects—with the possible exception of geometric subjects such as rock formations. However, some architectural subjects work well when shot under hard light—modern glass buildings, for example. Clouds help to reduce the hardness of light by acting as giant reflectors, bouncing light into the shadows of a scene. Too much cloud, however, will obscure the sun, softening the light so that there are few if any shadows. This isn't the ideal light for an expansive view of a landscape or an architectural subject, but it is useful for shooting smaller details such as fungi or interiors.

The raking light from the sun when it's close to the horizon at sunrise or sunset helps to reveal texture and detail in both landscape and architecture—these are generally the most interesting times to be out shooting both for color and black and white photography. The time and the direction that sun rises or sets alters throughout the year so it's important to check where the sun is going to be, relative to your subject, at your chosen time. There are many resources, including smartphone apps and websites, that will help you calculate these details ahead of time.

Above: Hard light is necessary for subjects such as this sculpture to help define the form and texture of the piece.

Right: Soft, overcast light is generally best avoided when shooting larger landscape views. However, if there is detail in the clouds, you can give the sky a brooding, heavy feel by darkening it considerably in postproduction.

LANDSCAPE

There are many different types of landscape subject, each with their own challenges and rewards. Apart from the weather and time of day, there will be other factors you will need to take into consideration. For instance, shooting by the coast will involve thinking about tides and whether your intended shots are even possible.

For all types of landscape photography, you'll also need to think about the length of time it will take to get to a location. If you want to arrive for a specific event, such as sunrise, you'll need to work backwards from that time, taking off travel time (by car, if relevant, and walking) and any time necessary to set up your camera. The length of

time it takes to set up can be shortened if you've pre-planned a shot. If not, you'll need to allow plenty of time to find a composition without panicking.

In many respects, winter is the ideal time for black and white landscape photography. Some seasons are associated with vibrant colors, including flowers in the spring and leaves in the fall. A cold, stark winter can offer opportunities for capturing very graphic imagery, which will be more about line, shape, and texture than color.

Below: Snow reduces the complexity of a landscape, allowing you to shoot very minimalist, graphic imagery.

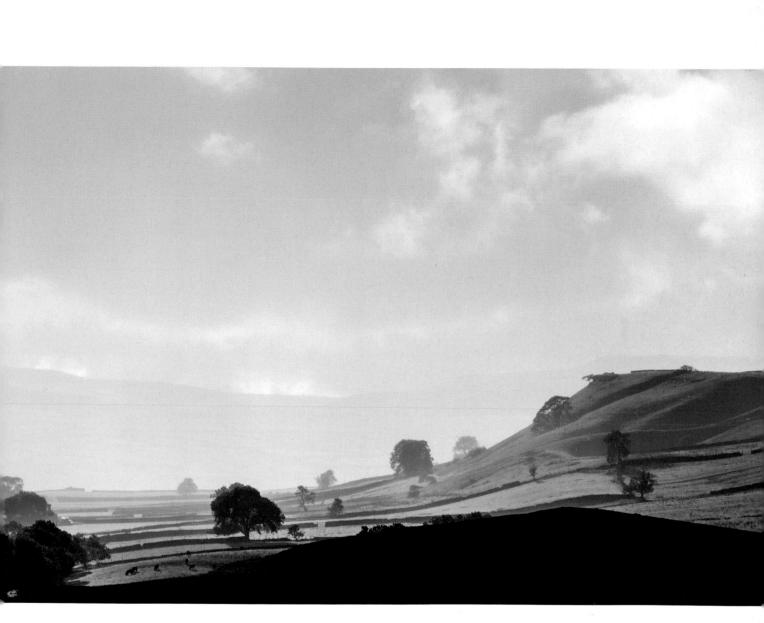

Above: You're at the mercy of the weather when shooting outdoors. The weather controls the quality of the sunlight falling onto the landscape. Here, patchy cloud has cast interesting shadows across the scenery, while an incoming rain shower has softened details in the far distance. Mixed weather like this means working intuitively and quickly as the effects of light on the landscape can be frustratingly fleeting.

ARCHITECTURE

There are essentially two ways to shoot architecture: formally or informally. The approach you choose will be determined by your own feelings towards the subject.

FORMAL APPROACH

Shooting architecture in a formal manner requires precision. Your camera needs to be kept parallel to your subject so that the lines of the building appear perfectly vertical in the final image. This involves the use of tripods and spirit levels, so it's not a quick process. You'd be forgiven for thinking that you need to use wide-angle lenses exclusively when shooting architecture. Buildings are usually tall and often the only way to fit them into a shot—and still keep everything vertical—is to use a wide-angle lens. Unfortunately, wide-angle lenses can be prone to distortion, often readily apparent when shooting architecture. One solution is to use what is known as a shift, or perspective-control, lens. These lenses have a feature that enables the front of the lens to move up or down, so you can frame the building as required, and still keep the camera parallel to the subject.

However, shift lenses are expensive and—unless architecture is your specialty—hard to justify. Another solution, if physically possible, is to put some distance between you and your chosen subject and use a longer focal length lens. By doing this, you'll be able to keep your camera, if not parallel, at least at a shallower angle relative to your subject.

INFORMAL APPROACH

The reason for keeping the camera parallel to your subject is to avoid a problem known as "converging verticals". This is an effect seen when an architectural subject appears to be falling backwards in an image. It's caused by the act of tipping the camera up to fit the architectural subject into the image frame. However, it's an effect that can be exploited if you take a more informal approach to

Above: This image of a lighthouse was shot with a telephoto lens from some distance away. This allowed me to keep the lighthouse upright in the image without it appearing to tip over.

architectural photography. Shooting architecture informally is something that can be done intuitively and without a tripod. Informal shooting is about conveying your personal feelings for a building. Exploiting the visual effect of converging verticals can help to emphasize the way in which a building towers over people. The key is to be bold and not half-hearted in how you compose your shot.

Above: This is a very informal and slightly mischievous shot of a 66ft-(20m-) high sculpture. Compare this image to the more formal approach I took to the same subject on pages 76 to 77.

DETAILS

The temptation when shooting landscape or architectural subjects is to always shoot the "bigger" picture—the wide-open vista or the entire building. However, interesting details can often be found that will tell a more nuanced and intimate story of your chosen subject.

FORMAL APPROACH

Shooting details is best achieved using a longer focal length lens. This is partly because some interesting or important details—particularly on buildings—may be far above your head. In these cases, such details would appear vanishingly small if a wide-angle lens were used. Another good reason to use a longer focal length is to crop out unwanted or distracting elements that may compete visually with your intended subject. The final reason is more creative. Using a longer focal length lens at maximum aperture will make it easier to minimize depth of field and separate your subject from its background.

For smaller details, you may need to use a macro lens. These lenses allow very close focusing, far closer than a standard lens. A true macro lens projects an image of the subject onto a camera's sensor that is the same size (or larger) as the subject itself. The lens is referred to as having a 1:1 reproduction ratio. The potential problems when using a macro lens for detail photography include a very restricted depth of field and a greater likelihood of camera shake. The latter is particularly a problem, as you often need to use very small apertures in order to achieve a reasonable spread of sharpness in the image. For this reason you either need to illuminate your subject quite intensely or make use of a tripod to keep the camera steady (see pages 18 and 152). Because of a lack of depth of field when shooting details, it's important to select your focus point very carefully. Shooting details is very similar to shooting still life, and many of the techniques covered in the Lesson on still life photography (see page 160) are applicable.

Above: This image was shot with a 100mm lens. Using this lens allowed me to fill the frame with the subject and avoid unwanted detail either side.

Above: Simple compositions work well when shooting details. For this image I shot upwards towards the sky to avoid including buildings and other distractions within the image space.

KEEPING THE CAMERA STEADY

Landscape and architectural photography both benefit from a rigorous approach to working. One key part of the process is keeping the camera steady. This can be difficult as slow shutter speeds are often necessary with the smaller apertures required to maximize depth of field. The problem is compounded by the fact that the most sympathetic light for landscape and architectural subjects is often at the extreme ends of the day—cityscapes are also particularly photogenic at dusk, when buildings are artificially lit.

Keeping a camera steady invariably means using a tripod. However, even tripods won't give the necessary support if they're used incorrectly. When setting up a tripod ensure that the legs are splayed out at their maximum angle. Set the legs so that the center column is at right angles to the ground. If it isn't, your tripod and camera may tip over; on uneven ground it's often necessary to set the tripod legs to different lengths to prevent tipping. If the ground isn't solid, push your tripod down firmly to settle it, and don't move about during exposures as this may cause the tripod to shift slightly. Avoid using the center column, if possible, as this raises the center of gravity of the camera and tripod, making the whole setup more unstable.

Using a remote release helps to avoid knocking your camera accidentally when you press the shutter button. If you shoot with a DSLR, switch to Live View or turn on mirror-lock just before shooting. The mirror inside the camera can cause a slight vibration as it swings up during an exposure, resulting in a slight softness to images. Finally, if your lens or camera has built-in image stabilization or vibration reduction, turn it off. Some stabilization systems can actually become confused when a camera is perfectly steady and, ironically, cause an effect similar to camera shake that will mar an image.

Left: Shooting before sunrise or after sunset often means using shutter speeds that are significant fractions of a second, sometimes even whole seconds. Exposures of these lengths mean that it's impossible to handhold a camera and produce a sharp image.

VARIATIONS

Aim: Shoot at least five contrasting images of a chosen landscape or architectural feature at different times of the day, in different conditions, from different positions, and using different lens focal lengths.

Learning objective: To learn to photograph a landscape or architectural subject creatively, using varying perspectives and techniques.

Equipment checklist:
• Camera and zoom lens (or several prime lenses)
• Tripod (optional, but recommended)
• Postproduction software

Brief: Select a distinctive architectural or landscape feature that you can easily revisit a number of times over the course of a week. Shoot at least five shots (in color) of your chosen subject at different times of the day, and in different types of weather (such as in bright sunshine and overcast conditions). Vary the compositions you shoot by finding different viewpoints and using different lens focal lengths (include at least one detail shot). Try to make each image visually unique when compared to the others. By the end of the shooting stage, you should have a set of images varied in both composition and illumination. Import your images into your postproduction software. Convert each image to black and white using color filtration as appropriate. Apply any corrections, such as contrast or special effects (see pages 79 and 86), that you think would enhance an image.

TIPS

• If you choose to shoot an architectural subject, consider shooting one image at dusk—approximately 30 minutes after sunset. There should still be light in the sky at this time, which means that visual interest will be retained.

• A tripod is highly recommended when shooting in low light.

• Shoot using Raw for maximum image quality.

Left: Your position in relation to the subject and your choice of lens will determine the resulting perspective. Here, an extreme wide-angle lens has been used to dramatic effect.

Right: Contrast was increased in postproduction for this image to emphasize the brooding, stormy nature of the scene.

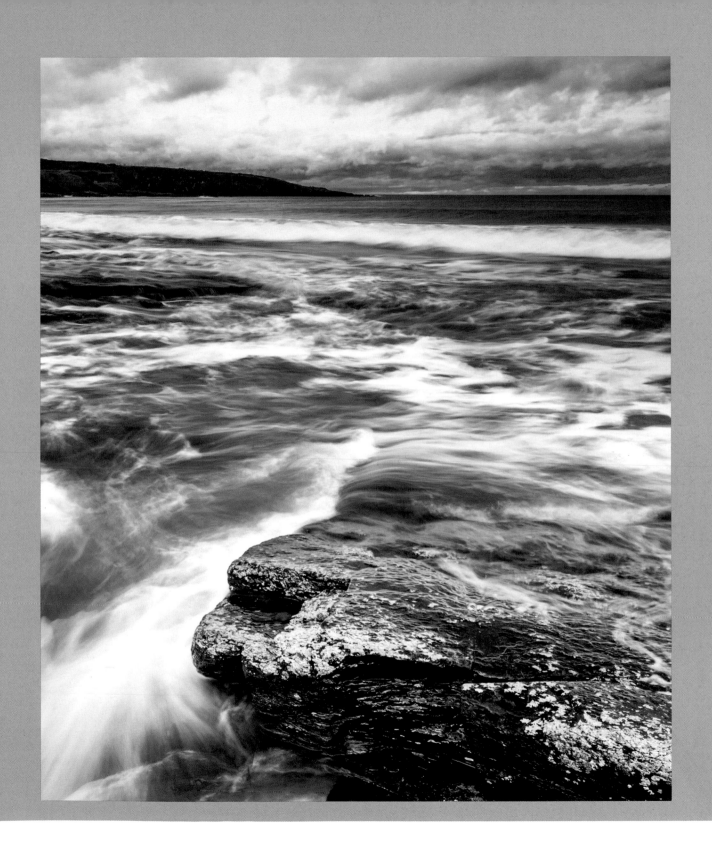

ANALYSIS

Print out the original five color images, followed by the black and white conversions. Work your way through your images, viewing the color version next to the black and white version. Alternatively, view the two versions of each image either side-by-side onscreen or consecutively onscreen (color then black and white).

Above: Modern glass buildings often work very effectively in black and white. As the glass is highly reflective, care must be taken with exposure when shooting with the sun directly on them. The one type of light that's least effective is overcast light when there's little of interest in the sky. This produces dull reflections which aren't visually interesting.

1 Assess each image initially in terms of its success as a black and white image in comparison to the original color version. Has anything been lost? Has anything being gained? If the former, consider what you could have done differently, either at the time of shooting or in postproduction.

2 Consider reconverting your images if you feel your conversions are lacking. There's nothing wrong with changing your mind about a conversion—darkroom printers often produce numerous versions of a print before finding the right technique.

3 Next, arrange your prints—or the order you view them onscreen—in terms of preference. Note the visual qualities of your favorite and least favorite images. Think about the differences between the two, particularly in terms of the composition and the light conditions. Composition and light are bound together in many ways—light often determines the optimum place to stand in relation to your subject. If the quality of the light is an important difference, consider reshooting your least favorite image at either a different time of day or under different lighting conditions to see if the image can be improved.

Above: Stormy conditions are often the most rewarding time to be out shooting landscapes. Care must taken both for your own personal safety and to avoid damaging the camera. This scene was shot in high winds, which meant I had to hold on to the tripod to stop it toppling over. The use of a tripod was necessary because I wanted to use a long shutter speed to capture the way the wind was dynamically blowing through the trees.

REFINE YOUR TECHNIQUE

Both landscape and architectural photography can be addictive. Fortunately, the fact that you need to be outdoors for both is good for your health and wellbeing. The key to progressing as a landscape or architectural photographer is, like most things in life, a matter of practice, practice, practice.

- To measure your progress, there's a lot to be said for revisiting a particular location or architectural subject a number of times over the course of a year. Doing this will make it easier to see how your photography knowledge and style are developing.

- Another good reason for revisiting a location or subject is that it will help you to gain an understanding of how seasonal change affects it. The seasons all bring different challenges and rewards for both landscape and architectural photography. It's also an interesting

challenge to repeatedly visit a location and shoot something new each time. Although this may sound daunting, this approach will help you to grow as a photographer. It's all too easy to repeat yourself, but longer term that won't be creatively fulfilling.

- A similar trap to avoid is repeating the work of others. This can be difficult when visiting an iconic location or subject. Often, it's next to impossible to find a unique viewpoint. For this reason, it's worth the effort to discover your own places. They may not be recognizable to most, but they will allow you to develop your own vision, free from the influence—conscious or otherwise—of others.

Left: Bamburgh Castle on the coast of northern England is a much-photographed landmark. Creating a black and white image of the castle is one way to make the image a bit different to all the others.

Right: There are many different styles of architecture. This means that there is no right or wrong way to shoot a building. Some styles of architecture suit a more formal approach, with the lines of the building kept straight and square-on—older architecture, such as stately homes or historic buildings, fall into this category. The stark, utilitarian lines of this modern building invited a more playful approach. The composition is therefore informal and more about shape and form than a record shot.

WHAT IS STILL LIFE?

The still life image has been a popular genre with painters for centuries. It's not surprising that it's been popular with photographers, too.

CAPTURING OBJECTS

A still life image, whether a painting or a photograph, has as its subject an inanimate object or objects—no matter how motionless it may be, a sleeping cat isn't, strictly speaking, a still life subject. A further refinement of the definition is that the objects in the still life are carefully arranged to form a pleasing composition by the artist. A still life isn't an image of objects found and left in situ, in other words—so an image of a statue in a museum isn't a still life, unless you've had permission to move it.

To further complicate matters, the artist not only has to arrange his or her subject in a pleasing way, the subject also has to be lit sympathetically. This means that producing a still-life image—even a photographic image—can take time to prepare and create. This, however, is the joy of creating a still life image—exercizing complete control over the final photograph; although creating a portrait image has many similarities, ultimately it's a collaborative process between the artist and the subject.

Right: Is this a still life image? I'd say not—this was a "grab" shot, taken quickly and is, strictly speaking, more of a documentary shot.

Below: Setting up a still life doesn't have to be complicated. This shot was created in approximately five minutes by placing the subject on a white sheet of card. A desk lamp was placed just to the right of the subject, with the angle of the lamp adjusted until the shadow looked interesting.

CHOOSING A SUBJECT

Theoretically, a still life subject can be any size. Typically, however, these images tend to feature subjects that are relatively small. This means that it's not necessary to work in a studio to shoot a still life photograph.

Still life images can be set up on a table in an ordinary household room, if necessary. Working on a small scale also means that still life images don't need expensive or complicated lighting setups. Although flash or other supplementary lights are useful, daylight from a window is perfectly acceptable—although the light may need modifying using reflectors.

You'll need to think in black and white when choosing your subject—don't pick subjects that rely on color for impact. Objects with an interesting texture or shape will work, particularly if lit sympathetically. As with most photography, you'll ultimately be more inclined to work at the photo if the subject is of interest to you personally. Objects that have sentimental value are ideal to practice with, as you'll have a personal investment in that object. If you decide to shoot more than one object, make sure that they have a connection. Including two or more randomly-chosen objects will be visually puzzling to whoever looks at your photograph later.

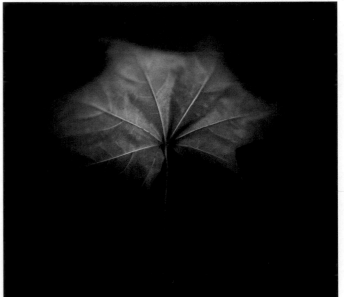

Above right: Still life subjects don't need to be three-dimensional. These rose leaves were arranged on a lightbox and then shot from directly overhead.

Right: How you shoot and process your still life will depend on your feelings towards the subject. I've created a heavy, sombre image of this autumnal leaf. Compare this to the high-key approach to the leaves in the image above.

Above: When shooting still life subjects close-up, focus accurately on the part of your subject you want to be sharpest. Limited depth of field becomes an increasing problem the nearer you place your camera to the subject. In the image above I focused on the stalk of the apple as I felt this was the focal point and so should be pin-sharp.

BACKGROUND

The background is almost as important as the subject. Try not to choose a background that's too busy as this will confuse the outline of your subject—unless the background is out of focus.

If you use a plain background, think carefully about the color. A color that contrasts with that of your subject will make it easier to adjust the brightness of the background relative to the subject in postproduction. Backgrounds should be relevant and sympathetic to the subject, too. An antique would look odd against a modern, space-age background, for example.

Below: A busy background can be simplified by using a large aperture to restrict depth of field. This technique is more effective when a telephoto lens is used, and also when the background is relatively distant from the main subject.

Above: A light yellow background was used for this shot. This light, but not white, background helps to define the shape of the metronome. The shape would have been lost if a darker background had been used.

FINAL CHECKS

Check your subject for any blemishes such as dust or fingerprints. This is particularly important if your subject has a high-gloss finish.

Blemishes can be cloned out in postproduction but this will take longer than spending the time cleaning the objects before shooting. Another potential problem to be aware of when shooting high-gloss subjects is specular highlights. These are bright hotspots caused by hard point-light sources. If in doubt, shoot a test shot and check the results carefully. This is particularly important when using flash, as you won't see the effects until you've made the test shot.

If your subject is small and three-dimensional, you'll need to use a small aperture to ensure that everything is sharp. The shorter the camera-to-subject distance, the less depth of field there'll be. You may find yourself needing to use a lens's minimum aperture to ensure front-to-back sharpness.

Where you focus will be important. Remember that depth of field extends further back from the focus point. It's a good idea to either bias the focusing to the front of your subject or to the part of your subject that needs to be critically sharp.

Below: Your still life subjects don't need to be critically sharp from front-to-back. Using a large aperture to restrict depth of field will introduce visual ambiguity to your image.

SHOOT A STILL LIFE

Aim: Shoot a series of five photographs of an object in your home, using a background and several different lighting effects.

Learning objective: To learn how to prepare and photograph creative still life images, and understand the effects of using different indoor lighting setups.

Equipment checklist:
• Camera and zoom lens (or several prime lenses)
• Tripod
• Off-camera flash or lighting system
• Still life subject
• A background

Brief: Select a suitable subject for a still life from around your home. Look for objects that have an interesting shape or texture and, most importantly, will look good in black and white. Next, find or make a suitable setting or background for your subject. This can be as simple or as complex as you like, but simple is often better and generally won't detract from your subject—for instance, a sheet draped over a box so that it forms both a background and a foreground for your subject would work well.

Whatever your setting, think about the colors of the background and how these will convert to black and white compared with your subject. Mount your camera on a tripod and set up your still life composition. Once you're happy with the composition, shoot one image with your flash or light as close to your camera as possible—if you're using flash, mount it on the camera. Then move the flash (or light) to the right of your subject and shoot again. Shoot three more images, one with the flash to the left of the subject, one with the light directly above, and one above and slightly behind your subject. Check as you shoot that the light itself doesn't intrude into the image space or cause flare. By the end of the session, you should have five shots. Convert all of them to black and white using a consistent method.

Remember that shooting a successful still life image requires thought and the time to work out problems such as lighting and the setting for your subject.

Left: This subject was shot with a soft, directional light from below the bottom of the image.

TIPS

• Clean your subject before shooting, particularly if it has a glossy surface. Dust can be cloned out in postproduction but time is saved by a quick clean before shooting.

• Use a longer focal length lens and step back from your subject for a more natural perspective.

• Depth of field may be limited so focus carefully. Bias focusing towards to the front of your subject. Depth of field always extends further back from the focus point than ahead of it.

• Set up your camera on a tripod to ensure that there is a consistency to the images shot during this project.

Above: Care must be taken with metallic subjects to avoid bright hotspots from lights. For this shot of a brass horn, I softened the light from an off-camera flash by firing it through a diffusion screen.

ANALYSIS

Print out the five shots and then lay them out in order of shooting or view each image consecutively on your computer screen.

Above: To keep black backgrounds black, try to avoid the light that illuminates your subject falling on to your background. Conversely, using a pure white background often requires the use of a second light for the background.

1 Assess each image carefully, looking at the way in which the direction of the light changes where shadows fall. Note which lighting direction conveys a sense of the shape of the subject most effectively and also which doesn't.

2 Assess each image again and then rearrange the images in order of preference. Think about what visual qualities your favorite image has compared to your least favorite. This could be because of the way that the lighting creates a sense of depth. It could also be because of the way that light falls across your subject—the position of any highlights or the direction of shadows across the subject or background. When looking at your least favorite image, note why that particular lighting scheme fails. Think about whether this is a fundamental problem with the lighting scheme or whether the problem could be solved with a small change in the direction of the light or by the use of some accessory, such as a reflector to push light back into a particular area of the subject. Consider reshooting the image using your solution.

3 Look closely at the background in each image. Has the lighting direction caused the background to be more or less prominent in the shots? Successful still life photography requires you to think about how the background is lit as much as the subject itself. You may need to add additional illumination to a white background to ensure that it's rendered as white (or near white) in the final photograph. Black backgrounds benefit from being shaded from any light that's illuminating your subject.

Left: Transparent and translucent objects work well against a dark background when they are backlit. However, care must be taken to avoid several pitfalls that can result in an unsatisfactory image. Glass is highly reflective. If any light shines on you or your camera it's likely to cause a reflection. Angle the light so that none falls on you, wear dark clothing, and use a telephoto lens so that you can stay at a distance from your subject. Backlighting can also cause flare. To avoid this, use a lens hood or shade the light so that your camera is essentially in shadow, still ensuring that your subject is still adequately lit.

REFINE YOUR TECHNIQUE

The softness or hardness of the light you use is as important as its direction. Flash and domestic lamps produce a very hard light, particularly when placed close to your subject (distance softens a light source).

- Light sources, such as flash, can be softened through the use of accessories such as a softbox. A softbox features a translucent diffusion panel that effectively increases the size of the light emitted by the flash. Softboxes are commonly used when shooting both portraits and still life subjects. The larger the softbox, the more diffused and softer the light created. If portraiture or still life appeals as a subject—and you intend to use flash or a studio lamp regularly—then a softbox is an essential piece of equipment.

- Lighting a two-dimensional subject is fairly straightforward, but lighting a three-dimensional subject, and even multiple subjects, evenly takes time to get right. It's important to avoid uneven lighting that would cause one part of the scene to be more brightly lit than another—typically, the area closest to the light is the most brightly lit. Using a softbox will help to spread light more evenly. Another useful tool is a reflector than can be used to bounce light around the scene as necessary.

- Once you've set up a still life, it's worth shooting a test shot and assessing the exposure across the entire image, and then taking remedial action if the exposure isn't to your satisfaction.

Left: For this image, a hard light would have been inappropriate—the soft, almost shadowless light helps to create a gentle, airy atmosphere that suits the subject.

Above: If you're using artificial light sources, such as flash, you need to be able to control ambient light levels, too. This can be achieved using blinds or curtains, or even waiting until night falls. This image was shot in a darkened room so that only the supplementary lights I used illuminated the subject.

GLOSSARY

Aberration An imperfection in the image caused by the optics of a lens.

AE (autoexposure) lock A camera control that locks in the exposure value, allowing an image to be recomposed.

Angle of view The area of a scene that a lens takes in, measured in degrees.

Aperture The opening in a camera lens through which light passes to expose the sensor. The relative size of the aperture is denoted by f-stops.

Autofocus (AF) A reliable through-the-lens focusing system allowing accurate focus without the user manually turning the lens.

Bracketing Taking a series of essentially identical images with a variation in one shooting function between shots. The concept of bracketing is usually associated with exposure, with the exposure adjusted positively, negatively, or both during the bracketing process. However, some cameras also feature focusing bracketing in which the focus distance is adjusted between shots. Automated exposure bracketing is often shortened to AEB.

Buffer The in-camera memory of a digital camera.

Camera shake Image fault caused by camera movement during exposure.

Center-weighted metering A way of determining the exposure of a photograph, placing importance on the light meter reading at the center of the frame.

Chromatic aberration The inability of a lens to bring spectrum colors into focus at the same point.

Color temperature The color of a light source expressed in degrees Kelvin (K).

Compression The process by which digital files are reduced in size.

Contrast The range between the highlight (brightest) and shadow (darkest) areas of an image, or a marked difference in illumination between colors or adjacent areas.

Depth of field (DoF) The amount of an image that appears acceptably sharp. This is controlled by the aperture: the smaller the aperture, the greater the depth of field.

DPOF Digital Print Order Format.

Diopter Unit expressing the power of a lens.

Distortion A lens fault that causes what should be straight lines in an image to bow outwards from the center (referred to as barrel distortion) or inwards (referred to as pincushion distortion).

dpi (dots per inch) Measure of the resolution of a printer or scanner. The more dots per inch, the higher the resolution.

Dynamic range The ability of the camera's sensor to capture a full range of shadows and highlights.

Evaluative metering A metering system whereby light reflected from several subject areas is calculated based on algorithms.

Exposure The amount of light allowed to hit the sensor, controlled by aperture, shutter speed, and ISO. Also, the act of taking a photograph, as in "making an exposure".

Exposure compensation A control that allows intentional over- or underexposure.

Fill-in flash Flash combined with daylight in an exposure. Used with naturally backlit or harshly side-lit or top-lit subjects to prevent silhouettes forming, or to add extra light to the shadow areas of a well lit scene.

Filter A piece of colored or coated glass or plastic placed in front of the lens.

Focal length The distance, usually in millimeters, from the optical center point of a lens element to its focal point.

fps (frames per second) A measure of the time needed for a digital camera to process one image and be ready to shoot the next.

f-stop Number assigned to a particular lens aperture. Wide apertures are denoted by small numbers such as f/2; and small apertures by large numbers such as f/22.

Highlights The brightest parts of an image.

Histogram A graph used to represent the distribution of tones in an image.

Hotshoe An accessory shoe with electrical contacts that allows synchronization between a camera and a flash.

Hotspot A light area with a loss of detail in the highlights. This is a common problem in flash photography.

Incident-light reading Meter reading based on the light falling on the subject.

Interpolation A way of increasing the file size of a digital image by adding pixels, thereby increasing its resolution.

HDMI High Definition Multimedia Interface.

ISO (International Organization for Standardization) The sensitivity of the sensor measured in terms equivalent to the ISO rating of a film.

JPEG (Joint Photographic Experts Group) An image file format found on digital cameras. JPEG compresses image data, losing some detail in the process. JPEG

compression can reduce file sizes to about 5% of their original size.

Lens A group of shaped glass elements that focuses light on the digital sensor (or film) inside a camera. The prime characteristic of a lens is its focal length, which (depending on the size of the sensor) determines the angle of view.

LCD (liquid crystal display) The flat screen on a digital camera that allows the user to compose and review digital images.

Macro A term used to describe close-focusing and the close-focusing ability of a lens.

Manual focus Adjusting the focus distance of a lens by turning the focus ring by hand.

Megapixel One million pixels equals one megapixel.

Memory card A removable storage device for digital cameras.

Metering Act of measuring the amount of light falling on a scene to determine the required exposure.

Mirrorless Common name given to a camera that doesn't have a reflex mirror (*see SLR*). The photographer views a live image streamed from the digital sensor to an LCD.

Monochrome A synonym for black and white photography.

Noise Colored image interference caused by stray electrical signals.

Overexposure A result of allowing too much light to reach the digital sensor during exposure. Typically the highlights in an overexposed image will be burnt out to pure white and the shadows unnaturally bright.

PictBridge The industry standard for sending information directly from a camera to a printer, without having to connect to a computer.

Pixel Short for "picture element"—the smallest bits of information in a digital image.

Predictive autofocus An autofocus system that can continuously track a moving subject.

Raw The file format in which the raw data from the sensor is stored without permanent alteration being made.

Red-eye reduction A system that causes the pupils of a subject to shrink, by shining a light prior to taking the flash picture.

Remote release A device used to trigger the shutter of a tripod-mounted camera at a distance to avoid camera shake. Also known as a "cable release" or "remote switch."

Resolution The number of pixels used to capture or display an image.

RGB (red, green, blue) Computers and other digital devices understand color information as combinations of red, green, and blue.

Rule of Thirds A rule of thumb that places the key elements of a picture at points along imagined lines that divide the frame into thirds.

Sensor A microchip consisting of a grid of millions of light-sensitive cells—the more cells, the greater the number of pixels, and the higher the resolution of the final image. The two most commonly used types of digital sensor are CCD (or charge-coupled device) and CMOS (complementary metal-oxide semi-conductor).

Shadows The darkest parts of an image.

Shutter The mechanism that controls the amount of light reaching the sensor, by opening and closing.

SLR A contraction of single lens reflex. Describes a camera that allows a photographer to see the image projected through the lens by directing the image to the viewfinder using a reflex mirror.

Spot metering A metering system that places importance on the intensity of light reflected by a very small portion of the scene.

Teleconverter A lens that is added to the main lens, increasing the effective focal length.

Telephoto A lens with a large focal length and a narrow angle of view.

TTL (through the lens) metering A metering system built into the camera that measures light passing through the lens at the time of shooting.

TIFF (Tagged Image File Format) A universal file format supported by virtually all relevant software applications. TIFFs are uncompressed digital files.

Underexposure A result of allowing too little light to reach the digital sensor during exposure. Typically, the highlights in an underexposed image will be muddy and the shadows dense and lacking in detail.

USB (universal serial bus) A data transfer standard, used by most cameras when connecting to a computer.

Viewfinder An optical system used for composing, and sometimes for focusing the subject.

White balance A function that allows the correct color balance to be recorded for any given lighting situation.

Wide-angle lens A lens with a short focal length and consequently a wide angle of view.

Zoom A lens with a variable focal length.

USEFUL WEB SITES

GENERAL

Digital Photography Review *www.dpreview.com*
On Landscape *www.onlandscape.co.uk*

PHOTOGRAPHERS

David Taylor *www.davidtaylorphotography.co.uk*

PHOTOGRAPHIC EQUIPMENT

Canon *www.canon.com* DSLRs, CSCs, compact cameras, and proprietary lenses; printers and photographic paper.

FujiFilm *www.fujifilm.com* CSCs, compact cameras, and proprietary lenses; photographic paper; film products.

Giottos *www.giottos.com* Tripod manufacturer.

Gitzo *www.gitzo.com* Tripod manufacturer.

Leica *www.leica-camera.com* Digital and film rangefinder cameras, medium-format DSLRs, and proprietary lenses.

Manfrotto *www.manfrotto.com* Tripod manufacturer.

Nikon *www.nikon.com* DSLRs, CSCs, compact cameras, and proprietary lenses.

Olympus *www.olympus-global.com* CSCs, compact cameras, and proprietary lenses.

Panasonic *www.panasonic.net* CSCs, compact cameras, and proprietary lenses.

Ricoh/Pentax *www.ricoh-imaging.com* DSLRs, CSCs, compact cameras, and proprietary lenses.

Sigma *www.sigma-photo.com* DSLRs, compact cameras, and proprietary lenses (plus third-party lenses for Canon, Micro Four Thirds, Nikon, Pentax, and Sony mounts).

Sony *www.sony.com* DSLRs, CSCs, compact cameras, and proprietary lenses.

Tamron *www.tamron.com* Third-party lenses for Canon, Nikon, Pentax, and Sony mounts.

3 Legged Thing *www.3leggedthing.com* British tripod manufacturer.

Tokina *www.tokinalens.com* Third-party lenses for Canon, Nikon, and Sony mounts.

Zeiss *www.zeiss.com* Third-party lenses for Canon, Fuji, Nikon, and Sony mounts.

PHOTOGRAPHY PUBLICATIONS

AE Publications *www.ammonitepress.com*
Photographer's Institute Press *www.pipress.com*
Black & White / Outdoor Photography magazine
 www.thegmcgroup.com

PRINTING

Epson *www.epson.com* Inkjet printers and photographic paper.

Hahnemühle *www.hahnemuehle.de* Fine-art photographic paper.

Harman *www.harman-inkjet.com* Fine-art photographic paper.

HP *www.hp.com* Inkjet printers and photographic paper.

Ilford *www.ilford.com* Photographic paper.

Kodak *www.kodak.com* Inkjet printers and photographic paper.

Lexmark *www.lexmark.com* Inkjet printers and paper.

Lyson *www.lyson.com* Third-party inks; continuous ink systems; photographic paper.

Marrut *www.marrutt.com* Third-party inks; continuous ink systems; photographic paper.

SOFTWARE

Adobe *www.adobe.com* Standalone imaging software (Photoshop, Photoshop Elements, and Lightroom).

AlienSkin *www.alienskin.com* Standalone imaging software; Photoshop and Lightroom plug-ins.

Apple *www.apple.com* Mac/iPad tablets; standalone imaging software (Aperture plus others).

Corel *www.corel.com* Standalone imaging software (PaintShop Pro plus others).

DxO *www.dxo.com* Standalone imaging software (Optics Pro plus others).

Phase One *www.phaseone.com* Medium-format digital backs; standalone imaging software (Capture One Pro plus others).

Photomatix *www.hdrsoft.com* Standalone HDR software (Photomatix Pro); Photoshop and Lightroom plug-ins.

PhotoPills *www.photopills.com* Landscape photography app.

INDEX

ACKNOWLEDGMENTS

Black and white usually means working in shades of gray. Fortunately, family and friends
make life more colorful. A big thank you should go to Colin Dixon, who helped teach me
the power and appeal of black and white photography. Thanks also need to be made to
Richard Wiles at Ammonite Press, Rob Yarham, Sue and Brian Brown, my wife Tania and
my parents, Carol and Bill Taylor, to whom this book is dedicated.

David Taylor

AMMONITE
PRESS